IMAGES
of America

EVERGREEN

ON THE COVER: EVERGREEN ACTIVITIES. Evergreen Summer Music Conference participants enlivened their Evergreen visits with hiking, horseback rides, swimming, fishing and rock climbing. The climbs were often led by the athletic Father Charles Winfred Douglas, who hiked and rode through much of the remote desert Southwest. (Courtesy of Jefferson County Historical Society.)

IMAGES
of America

EVERGREEN

John Steinle

ARCADIA
PUBLISHING

Published by Arcadia Publishing
Charleston, South Carolina

Printed in the United States of America

Library of Congress Control Number: 2017931432

For all general information, please contact Arcadia Publishing:
Telephone 843-853-2070
Fax 843-853-0044
E-mail sales@arcadiapublishing.com
For customer service and orders:
Toll-Free 1-888-313-2665

Visit us on the Internet at www.arcadiapublishing.com

This book is dedicated to Linda Kirkpatrick for her love of the Evergreen community, which has been sustained in so many vital ways through her efforts, and for her invaluable advice and assistance in writing this book.

CONTENTS

Acknowledgments 6

Introduction 7

1. 1859–1880 9

2. 1880–1900 23

3. 1900–1920 37

4. 1920–1940 51

5. 1940–1960 69

6. 1960–1980 83

7. 1980–1990 99

8. 1990–2009 113

Bibliography 126

Index 127

Acknowledgments

Many people made this book possible. Among them are Diane Fuchs, past president; Elaine Hayden, president; and the Board of Jefferson County Historical Society for allowing use of the Jefferson County Historical Society photo collection. All photographs in this book, unless otherwise noted, are from this collection.

Meghan Vickers, coordinator, Hiwan Heritage Park, Jefferson County Open Space, for her invaluable help in locating and scanning photos from the JCHS collection, and allowing use of Hiwan Heritage Park's research information.

Linda Kirkpatrick, for supplying many of the photos and giving selflessly of her knowledge and advice.

Others who offered photos and advice include John Ellis, director of community relations, Evergreen National Bank; Kelly Green, executive assistant, and Ellen O'Connor, executive director, Evergreen Park and Recreation District; Matt Robbins, communications manager, and Tim Sandsmark, nature education supervisor, Jefferson County Open Space; Melissa van Otterloo, History Colorado; Betsy Hays, president and CEO and Sheralynn Austin-Gagne, operations manager, Evergreen Chamber of Commerce; Ron Ruhoff, expert photographer; Steve Snyder, executive director, and Stephanie O'Malley, Center for the Arts Evergreen; Tara Sieber, office and accounts manager, and Douglas Adams, CEO, National Repertory Orchestra; Shari Snead, graphics expert; Josh Trefethen, director, Evergreen Fine Arts Festival; Lynn Nestingen, executive director, Evergreen Children's Chorale; Angela Rayne, executive director, Humphrey History Park and Museum; Colleen Skates, Bootstraps; Paul Luzetski and Susan Blake, Evergreen Garden Club; Susan Kramer, executive director, Evergreen Chorale and Center Stage; Christopher Moore, pastoral administrator, Christ the King Catholic Church; Holly Breke, Evergreen Rotary Club; Melissa Leasia and Kathy Madison, Evergreen Audubon; Katherine Olde Porter, Olde's Garage; Sharon K. Smith, executive director, and Katie Stoner, Evergreen Christian Outreach; Craig Patterson, photographer; John Davis, Evergreen Players; Beth Foster, Mount Evans Hospice; Brockner family; Evergreen Fire Rescue; Newkirk family; Douglas Rouse; Jill Hansen, Lutheran Church of the Cross; Ann Dodson; Sylvia Graovac; Christina Seldomridge; David Weinacht, photographer; Terri Garst, Los Angeles Public Library; and Karen Meyer, stalwart proofreader.

Hank and Barbie Alderfer and Tom and Elaine Hayden for revealing the soul of Evergreen.

And my wife, Mary, for her patience, advice, and support.

INTRODUCTION

"It seemed to be the most beautiful spot my eye ever rested upon." These were the words of Thomas Bergen, one of the earliest settlers in the Evergreen area. Any account of Evergreen history has to center on the beauty and natural resources surrounding the community. Located in the foothills of the Rocky Mountains at more than 7,000 feet elevation, Evergreen offers magnificent views in every direction. To the northwest lies the massif of Mount Evans and the Bendemeer Range, while Bear Creek, originating on the slopes of Mount Evans, flows through the heart of Evergreen and fills Evergreen Lake.

You might be asking, "Where is Evergreen?" That can sometimes be a touchy subject. Evergreen is one among many unincorporated communities in western Jefferson County, Colorado. There are no official boundaries and no city government. You can use the postal delivery zone or the County Planning and Zoning boundaries as some sort of yardstick, but Evergreen's exact location can be in the mind of the beholder. Sometimes, Evergreen seems like Brigadoon, that other legendary place that appears and vanishes as imagination dictates.

Though Native American remains several thousand years old have been found in the Evergreen area, by the 1800s the Ute people were the dominant residents there. Arapaho and Cheyenne people also hunted, fished, and gathered lodgepoles throughout the western areas of Jefferson County, often clashing with Ute warriors. Isolated fur trappers searched for beaver pelts in the Evergreen area, but it was not until 1858 that large numbers of whites invaded what had been Native American land for centuries.

In the summer of 1858, small quantities of gold were discovered in the Front Range area. Thousands grasped at the straw of gaining riches in the Colorado mountains, competing for the ultimate prize of wealth and fame. Many "saw the elephant," failed to find gold, and went home. Others, such as Thomas Bergen and Johnny Everhardt, realized that the prospectors and miners needed food, lodging, and forage for their animals on their journeys to the gold-bearing mountain regions.

Ranching and lumber were the initial basis for Evergreen's economy. The lush forests surrounding the community offered seemingly limitless opportunities to harvest lumber, feeding the insatiable appetite of the railroads and the ever-expanding metropolitan area surrounding Denver. Likewise, Evergreen's mountain meadows, watered by Bear Creek, Troublesome Creek, and Cub Creek, not only provided forage for large numbers of livestock, but offered harvests of hay bountiful enough for local ranchers to sell off the surplus.

As early as the late 1860s, wealthy Denver residents began buying properties near Evergreen as mountain retreats. The entwined Evans and Elbert families were pioneers in this movement. The original Troutdale-in-the-Pines Cabins, the Brookvale resort, and numerous small hotels catered to the brave, original Evergreen vacationers. As access to the area became easier, wealthy summer residents built magnificent second homes such as Greystone Lodge and Camp Neosho (now Hiwan Heritage Park).

By 1920, Evergreen became a tourist mecca with the development of the Denver Mountain Parks system and famed hotels, resorts, and dude ranches. The nationally famous Troutdale-in-the-Pines Hotel has vanished, but the Brook Forest Inn and Marshdale Lodge (Marshdale is now

known as the Bears Inn and Bistro Restaurant) still offer great food and lodging to visitors who enjoy their rustic atmosphere.

Evergreen was not free of racial and religious prejudice. Early land deeds in the Evergreen area often specified that the property was to be sold to "Caucasian" families only. Multiple letters from Troutdale Hotel guests and staff as late as the 1940s clearly indicate that the hotel was actively discouraging Jewish guests from staying there.

From 1920 to 1942, the Evergreen area was the focal point of outdoor recreation in Colorado. After creation of Evergreen Lake in the late 1920s, ice skating was added to the growing list of recreation opportunities including fishing, boating, riding, hiking, rock climbing, or simply relaxing amid peace and quiet. Expansion and improvement of the Denver Mountain Parks system and local roads brought Evergreen within the recreation area known by Denver city planners as the "Recreation Fan". Arthur Carhart of the US Forest Service wrote in 1921 that usage of the "Recreation Fan" would make Denver's citizens "the most healthy city dwellers in the world."

After World War II, a unique array of volunteer arts, cultural, nature, and charity organizations was created by Evergreen's people, as the community grew through the development of new housing and amenities. The late 1940s and 1950s saw the origins of the Evergreen Players, The Evergreen Naturalists Audubon Society, Evergreen Artists Association, International Bell Museum, Evergreen Volunteer Fire Department, and other organizations signaling a small but thriving community.

A bohemian era of the 1960s and 1970s brought artists, musicians, and hippies to Evergreen. The most famous of the new residents was Willie Nelson, who bought acreage and a home along Upper Bear Creek. At the opposite end of the musical spectrum, Evergreen was home to the youth orchestra known successively as the Colorado Philharmonic and the National Repertory Orchestra. Weekly Friday-night brawls between hippies and cowboys at the local bars testified through black eyes and bruises to the political and social divide of that era.

The 1970s saw the creation of the Jefferson County Open Space system of magnificent parks. It was authorized in 1972 by voters alarmed at the rapid pace of suburban sprawl. The Open Space system, funded by a small percentage of county sales tax, now protects more than 50,000 acres. It includes the historic log mansion and pine grove now known as Hiwan Heritage Park, operated through a partnership with Jefferson County Historical Society. In 1969, voters approved creation of the Evergreen Park and Recreation District, offering multiple opportunities for recreation and enjoyment through two recreation centers, ball fields, outdoor classes and programs, and events at the Evergreen Lake House.

Construction of Interstate 70 in the 1970s led to massive changes. With much a much faster commute "down the hill", Evergreen became a bedroom community with a tremendous boom in population, housing, and "big-box" businesses.

Throughout the 1980s and 1990s, preservation of Evergreen's unique mountain surroundings, while allowing for controlled growth, became a priority. An Evergreen Community Plan was developed through collaboration among state and county agencies and local organizations. The Mountain Area Land Trust was founded, eventually saving thousands of acres of precious mountain acreage through purchase and easements. Additions to area amenities in the 1990s included a beautiful new county library building, and the massive log Evergreen Lake House. The historic Humphrey home and acreage opened as the Humphrey Memorial Park and Museum in 1995, adding to the area's cultural attractions.

Summer in Evergreen offers a smorgasbord of fun and enjoyable events, among them Evergreen Jazz Festival, annual Evergreen Rodeo and Rodeo Parade, Evergreen Fine Arts Festival, Summerfest, Big Chili, and performances by the Evergreen Players, Evergreen Chorale, Evergreen Children's Chorale, and others, all organized and staffed mostly through community volunteer efforts.

Evergreen's combination of Western heritage, historic structures, robust community organizations, and natural beauty make it unique. But the most extraordinary attribute of Evergreen is the community spirit shown by its residents in countless ways.

One

1859–1880

"Pike's Peak or Bust!" was the cry in 1859 as the Colorado Gold Rush reached its height. But relatively few prospectors struck it rich. A more stable living lay in harvesting the riches of the land and supplying the needs of the prospectors. As toll roads were constructed connecting the "flatlands" communities to the gold mines, the Bergen, Hicks, Mallett, Dedisse, and Strain families and others filtered into the remote area surrounding today's Evergreen. The Mount Vernon Toll Road was their lifeline, and the Bergens made a good living hosting overnight travelers and selling supplies to them.

With county boundaries being unofficial from 1859 to 1861, local rivalries naturally surfaced. Thomas Bergen and his friends established their own county known as Niwot County after the Arapaho chief Niwot, while the Mallett and Strain faction dubbed their rival county Spruce Park County. Hostility between the two competing counties almost led to gunplay on more than one occasion. The controversy only quieted after Congress established Colorado Territory in early 1861 and Jefferson County was formally created.

Due to the increasing area population, in 1876 rancher Dwight Wilmot and his family applied to the federal government for establishment of a post office. When asked to apply a name to it, the Wilmots replied "Evergreen," a natural response given the lush coniferous forests surrounding the area.

Thomas Bergen's son-in-law Amos Post built a substantial general store along the toll road route. Known as "The Post," the store became the post office, a mecca for local ranchers and farmers, and the nucleus of a developing business district.

The tiny community had spiritual as well as bodily needs. Methodists held services in local one-room schools but had no church building. A small Episcopalian congregation known as St. Mark's in the Wilderness was established by Bishop Randall in 1872, and a church building was finished two years later.

By the end of the 1870s, Evergreen had a name, local businesses, a church, and a cemetery. The village was the center of a thriving ranching and farming economy as Colorado became a state and the nation celebrated its centennial.

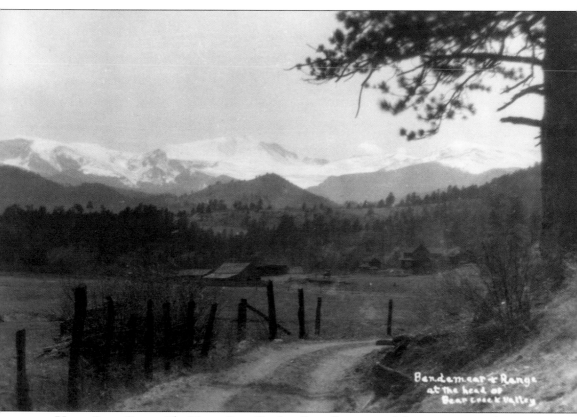

Bendemear + Range
at the head of
Bear Creek Valley

UPPER BEAR CREEK. The Upper Bear Creek valley offers some of the most spectacular views in the Evergreen area, looking toward Mount Evans. This photograph gives only a hint of the natural beauty to be seen in and around Evergreen. Ample resources of water, timber, and wild game led both Native Americans and early white settlers to the majestically beautiful Evergreen region.

CHIEF COLOROW. Colorow, leader of part of the Muwache band of the Ute people, was one of the Native American leaders encountered by early Evergreen settlers. In the spring, he visited his Council Tree on the Rooney Ranch property near Morrison, Colorado, to consult with fellow Ute leaders. The Council Tree still survives, and Colorow is remembered through Colorow Road and Colorow Cave. He died in 1888. (Courtesy of History Colorado.)

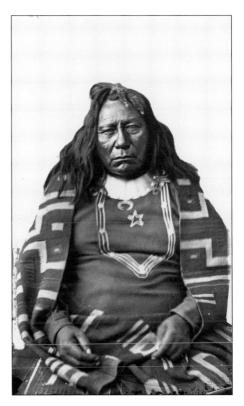

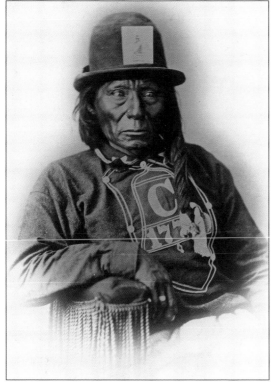

CHIEF WASHINGTON. Ute Chief Washington was leader of a band of Utes who camped at Hayward Junction near Evergreen in the 1860s, friendly to white settlers. Throughout the 1860s and 1870s, a series of treaties confined the Ute people to reservations, then took away much of the land originally granted to them. They gradually disappeared from what had been their mountain homeland in western Jefferson County. (Courtesy of History Colorado.)

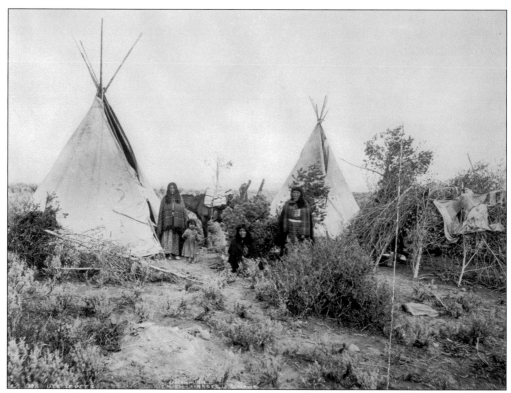

UTE INDIAN CAMP. This photograph was taken in southern Colorado in 1899. It shows the traditional Ute tipis set up, and a brush shelter on the right. Chief Washington's camp near Evergreen at Hayward Junction would have looked very similar. (Courtesy of History Colorado.)

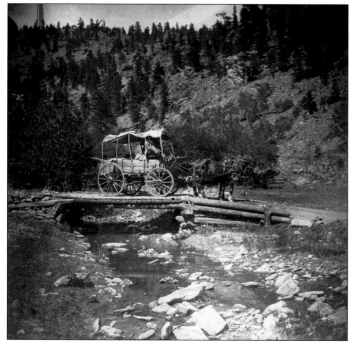

WAGON ROADS. Rough, difficult wagon roads offered the only access to Evergreen in its early history. The trip from Morrison to Evergreen involved crossing Bear Creek more than a dozen times on rickety bridges such as this one, which frequently washed out in flood times. Even the well-traveled toll roads were steep in places and difficult to navigate in bad weather. The lack of good travel routes limited growth and access to the mountain communities in western Jefferson County.

THE BERGENS. Thomas Bergen of Illinois journeyed to Colorado in 1859 in search of gold. Realizing that few would strike it rich, he settled along the Mount Vernon toll road to the mining areas, completing his first cabin on July 4, 1859. Bringing his wife, Judith, and children to Colorado, he established a successful ranch while housing and feeding travelers along the toll road. The original cabin site is commemorated by a historical marker in Bergen Park.

BERGEN RANCH. In 1865, the Bergens moved a few hundred yards down the toll road and established a new homestead near a spring that still runs. They built a two-story log home and a large barn with other outbuildings. This photograph shows the second Bergen site when it was owned by the Johnson brothers in the early 1900s. The barn may contain sections of the original Bergen structure.

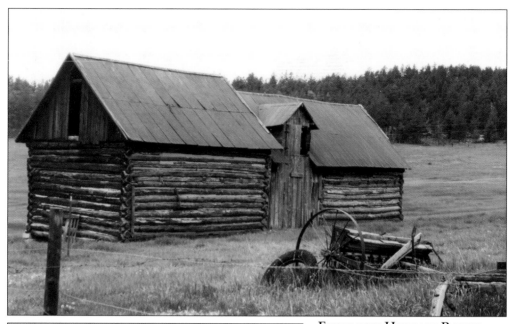

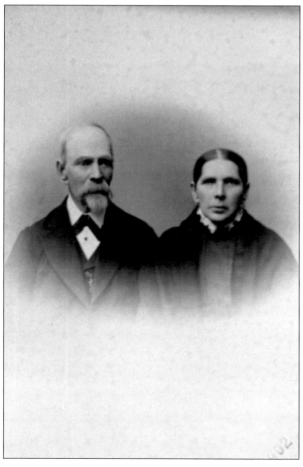

EVERHARDT-HERZMAN RANCH.
The log buildings on the former ranch property, among the oldest structures in Jefferson County, are listed in the National Register of Historic Places. Johnny Everhardt homesteaded the area about 1862, building a log cabin, barn, corrals, and a sawmill. He hauled hay by ox-drawn wagons to local mining camps. After his first cabin was burned by Native Americans, he worked out a truce with them and lived in peace.

HERZMANS. Charles and Mathilda Herzman purchased neighboring property from Johnny Everhardt around 1890. By then, they had been ranching in the area for years. Everhardt had been disabled in a logging accident; the Herzmans built him a log cabin and cared for him the rest of his life. The Herzmans operated their cattle ranch until 1949. Much later it was purchased, and the buildings were renovated, by the Hall family.

Gov. John Evans. John Evans (1814–1897) was born in Ohio, studied medicine, then moved to Illinois, founding several hospitals, the future Northwestern University, and the Illinois Republican Party. Appointed governor of Colorado Territory, he was complicit in the infamous Sand Creek Massacre in 1864. Though removed from office, he remained influential in economic and educational efforts, and he purchased ranch property near Evergreen in the late 1860s. (Courtesy of History Colorado.)

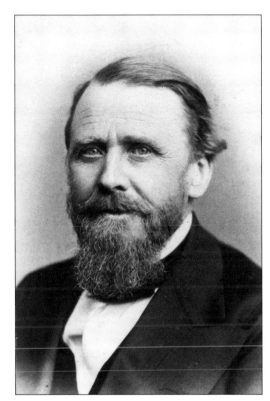

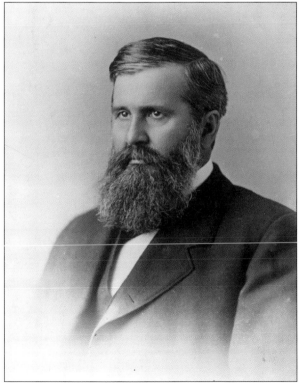

Gov. Samuel Elbert. Samuel Elbert (1833–1899) was a lawyer in Nebraska Territory when he attended the Republican National Convention in 1860, met Abraham Lincoln and John Evans, and became their political ally. Elbert served as territorial secretary under Evans. Elected to the Territorial Legislature, he was appointed by President Grant as territorial governor in 1873. He collaborated with Evans in developing his ranch. (Courtesy of History Colorado.)

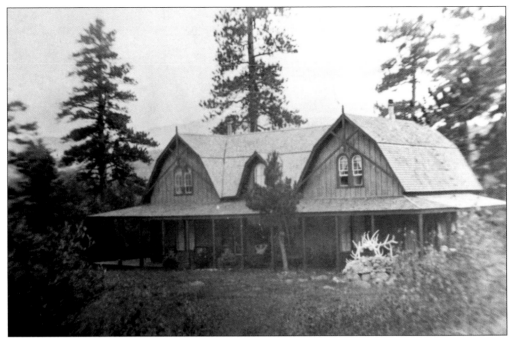

EVANS COTTAGE. Governor Evans had "The Cottage" built in 1869 to house his large family while on visits to the Evans Ranch. A relative recalled it as having "a good many rooms without being very large . . . running water was ingeniously provided by a little ditch from the creek, running through a wooden trough just outside the house." The Cottage burned about 1909, leading to various other construction projects by family members.

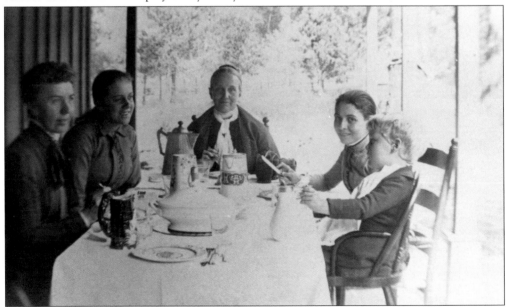

EVANS FAMILY. Certain luxuries were enjoyed by the Evans family, even when on their remote ranch. Having afternoon tea, pictured from left to right, are cousin Cornelia Gray Lunt, known as "Cousin Nina," daughter Anne Evans, Margaret Gray Evans (Governor Evans's wife), Cornelia Gray Evans, and grandson John Evans.

Dwight Wilmot. Dwight Wilmot, originally from Illinois, claimed ranch land in Evergreen about 1875. Seeing the need for a local post office, Wilmot applied to the government for one to be opened. When the government requested a name for the location, Wilmot and his family suggested "Evergreen" because of the beautiful local stands of pine and fir trees.

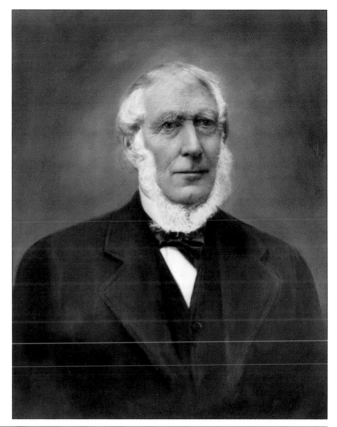

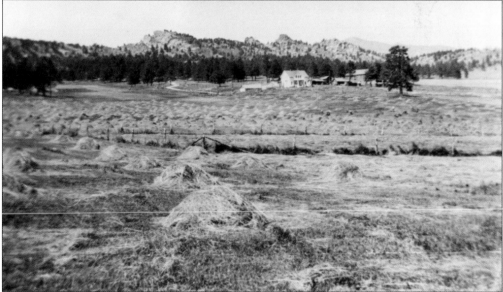

Wilmot Ranch. The extensive Wilmot Ranch was located along today's Buffalo Park Road. In this photograph, hay has just been harvested and stacked. The Wilmot house in the distance, more elaborate and well-constructed than many early ranch homes in the area, survives and has been restored by the Hardman family.

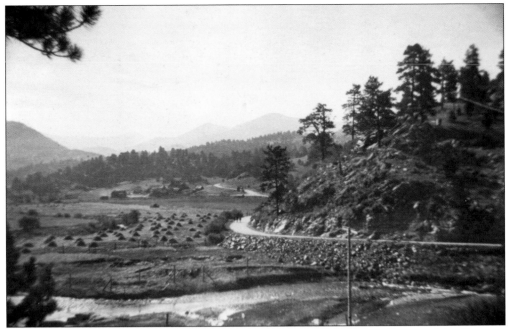

DEDISSE RANCH. Jules Cesar Dedisse and his family from France settled along Bear Creek in 1866. The ranching acreage produced rich, nutritious hay. The Dedisses also cleared an area for a community baseball diamond. The ranch was described as a "Mountain Eden" in an 1893 newspaper. In 1919, Denver Water Board acquired the Dedisse property through condemnation, later constructing Evergreen Dam. The former Dedisse Ranch site was then submerged beneath Evergreen Lake.

JULES CESAR DEDISSE AND HIS GRANDCHILDREN. The founder of the Dedisse Ranch poses proudly with his grandchildren in this photograph. Members of the Dedisse family still live in Evergreen and remain involved in community organizations and improvements.

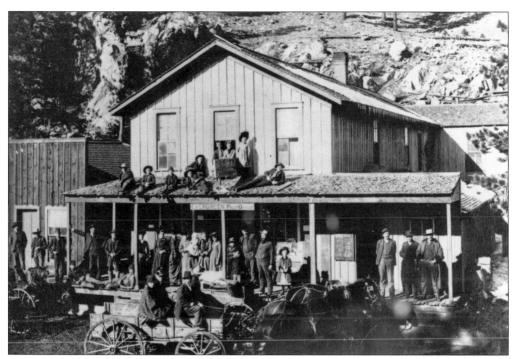

THE POST. The Post general store, operated by Amos Post and his family, opened in the mid-1870s. It was one of the first mercantile establishments within today's Evergreen area, and anchored the birth of a tiny business district along today's Evergreen Main Street.

POST FAMILY. Amos Post (center) and his wife, Sarah (far right), pose with their children. Daughter Martha Ann recalled that her father was a carpenter and builder who could "make tables, chairs, stools, even make a washing machine and a sleigh." The *Colorado Transcript* newspaper reported in 1871 that Amos found valuable silver ore near his home. Mysteriously, Amos does not seem to have followed up with a mining operation.

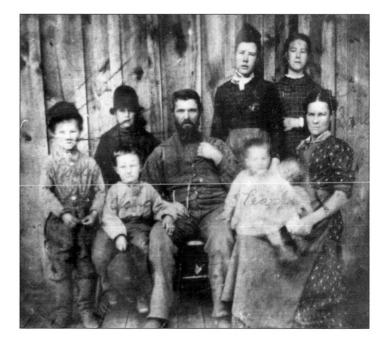

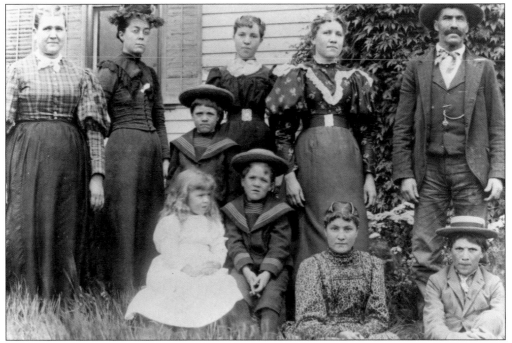

Roy Family. By the time the Roy family posed for this photograph in the 1890s, they had been part of the ranching community in Evergreen for some 20 years. Antoine Roy, on the far right, was one of the many French Canadians to settle in the Evergreen area, including the neighboring Vezina and Mallett families along Buffalo Park Road.

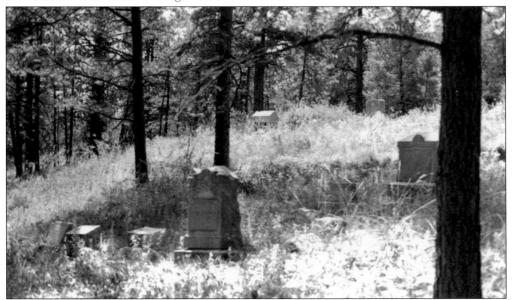

Bear Creek Cemetery. Burials began on the current cemetery land as early as 1871, even before local settler Edward Mallett donated land for the Episcopalian St. Mark's Church and cemetery around 1872. St. Mark's property was acquired by the Methodist Church and eventually by Dwight Wilmot, who led the effort to incorporate the cemetery in 1907. The cemetery's broken, steep terrain is a true testimony to the rough pioneer life of early Evergreen.

AMES RANCH (CRESWELL). In the 1860s, W.G. and Florence Ames built a tavern and stagecoach stop with a post office at a location they called Creswell, along the toll road just west of the Bergen Ranch. An 1873 newspaper article noted that Creswell was fading away, and by 1890 the Colorado Business Directory lists no businesses there. Today, nothing remains of Creswell except a small granary building located along County Road 63.

HICKS RANCH. Daniel and Celeste Hicks homesteaded a ranch on remote Upper Bear Creek in 1865 and named it Brookvale. The name for the area was later used by Thomas Sisty, who started up a successful resort nearby, with its own stagecoach route, in the 1870s. Hicks Mountain near Upper Bear Creek, now part of Denver Mountain Parks property, was named after the family. (Courtesy of Hank Alderfer.)

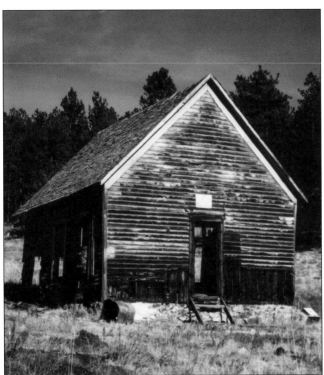

BERGEN SCHOOL. Thomas Bergen and Amos Post built the Bergen School in 1862. It was located along a roadway near Troublesome Creek that led from Bergen Park to the Morrison wagon road. Teachers earned $40 per month during the short school year. The school closed in the 1930s after construction of the new brick school in Evergreen, and the abandoned building blew down in the 1980s on a Super Bowl Sunday.

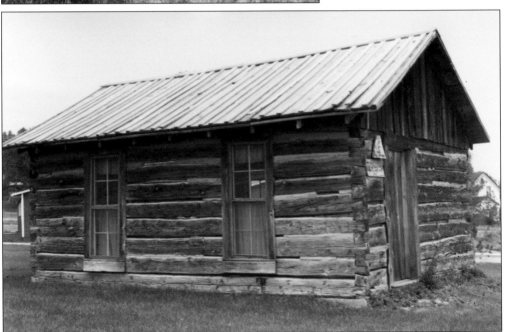

BUFFALO PARK SCHOOL. In 1877, the Roy, Vezina, and Mallett families living along Buffalo Park Road built this tiny school to provide an education for their children, and several family members taught there. As many as 22 students crowded into the 10-by-15-foot school, warmed by a potbelly stove. In 1967, the Evergreen Woman's Club had the building moved to the grounds of Wilmot Elementary School and renovated.

Two

1880–1900

The 1900 census reported that the Evergreen population reached 355 as ranching, farming, and the lumber industry expanded. By 1900, the business district in Evergreen grew to 24 businesses and two churches. At least seven sawmills were developed in the area to harvest the rich resources of timber. Besides harvesting huge amounts of hay, local ranchers and farmers grew root crops on a large scale. Swede John Johnson became so well known for the bountiful root crops grown at his Mountain Nook Ranch that he was called "Rutabaga" Johnson.

Successful resorts, such as Brookvale and Troutdale-in-the-Pines along Upper Bear Creek, plus small tourist hotels, offered accommodations for those brave souls risking travel along the rough wagon roads leading to the area in order to relax amid Evergreen's natural beauty.

These same factors drew wealthy families to build rustic retreats. To the already established Evans and Elbert extended families were added the Williams, Douglas, Bancroft, and Dailey families and others. A social divide developed between the year-round ranching and farming families, and the wealthier summer residents.

By 1890 the Methodists had taken over the former St. Mark's Episcopalian church building, and the former Stewart Hotel officially became the Episcopalian Mission of the Transfiguration in 1899. For the first time, Evergreen people had the benefit of two active congregations with well-supported church buildings.

Education grew more widespread than it had been in the past as the Bergen School and Buffalo Park School were joined by the Soda Creek School, Brookvale School, and Conifer School.

Without the benefit of traveling theatrical troupes, Evergreen residents created their own lively entertainment. An 1885 article in Golden's *Colorado Transcript* noted that a local group called the "Evergreen Lyceum" performed a minstrel show, along with "declamations, recitations and duets" and a drama entitled "The California Uncle". Residents also established social and moral organizations such as the Independent Order of Good Templars, Evergreen Lodge No. 22, part of a national temperance group. The Templars met at "Post Hall," perhaps the upper floor of Amos Post's store.

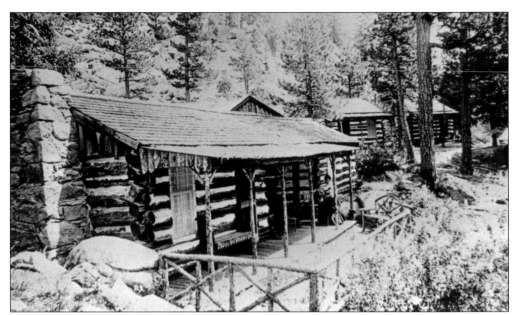

TROUTDALE CABINS. In the early 1880s, the Babcock family opened a complex of guest cabins along Upper Bear Creek, naming it Troutdale-in-the-Pines. The Babcocks also operated a small hotel in Evergreen and the restaurant at the Beaver Brook railroad stop on Clear Creek. Guests at Troutdale enjoyed fishing, swimming, hiking, riding, and exploring the beautiful surroundings, and it became one of the first tourist destinations in the Evergreen area.

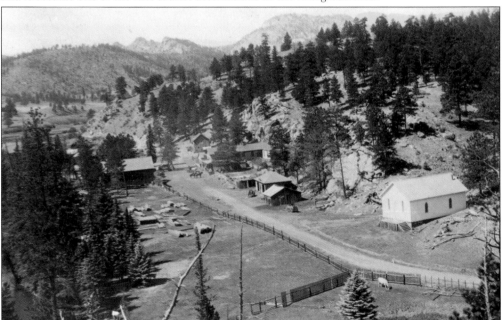

EARLY EVERGREEN VIEW. This view from about 1901 shows the Methodist Church on the lower right, with The Post general store on upper right. Crofutt's 1885 *Gripsack Guide to Colorado* noted, "Evergreen, Jefferson County, is a postoffice [sic] on Bear Creek . . . way up in the mountains . . . Timber is abundant, as well as game and trout. It is quite a resort for campers in the summer. Population in vicinity, 100; several saw-mills near."

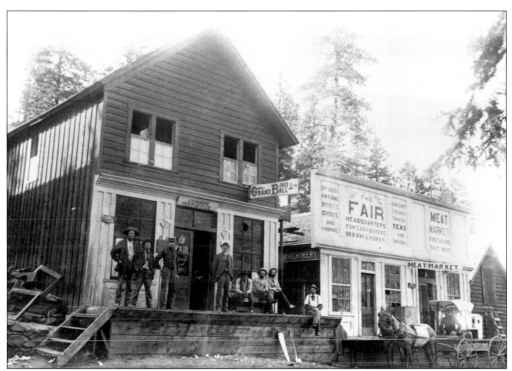

LUTHER'S STORE AND MEAT MARKET. Martin Luther, one of the original settlers of nearby Indian Hills, moved to Evergreen in the 1880s and opened a general store and meat market. Luther stands proudly in front of the store, which became the local post office. Evergreen must have been a lively place in the 1890s when this photograph was taken. The store features advertisements for a local Grand Ball, presumably in celebration of Independence Day.

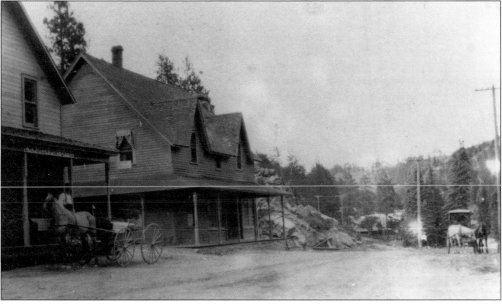

EVERGREEN MAIN STREET. The sparsely populated "upper" Main Street of Evergreen about 1900 shows a general store and post office on the left and the Evergreen Hotel on the right.

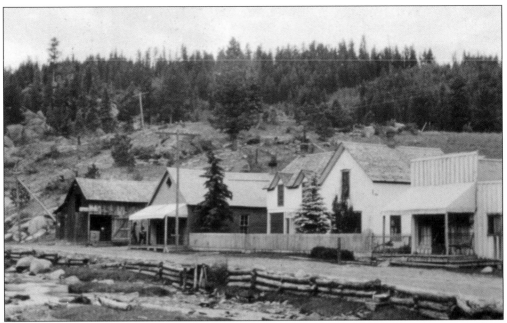

LOWER END. At the "lower" end of Main Street were located, from left to right, a livery stable, a pool hall, the Babcock Hotel, and another small, unidentified storefront. Dr. Jo Douglas reportedly bought the pool hall and put it out of business because of the evils therein, while the Babcock Hotel later became an Episcopalian retreat house known as St. Raphael's House and then the rectory for the Church of the Transfiguration.

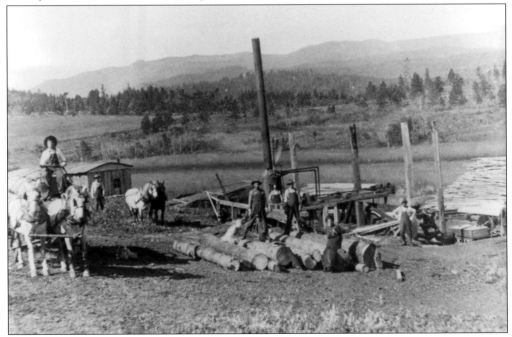

BERRIEN SAWMILL. Mountain area ranchers had to diversify their efforts to survive, and many were in the lumber business. Here, the Berrien family operate their portable steam-powered sawmill on the Berrien's Centaur Ranch. Much of the original ranch remains in Berrien family ownership.

26

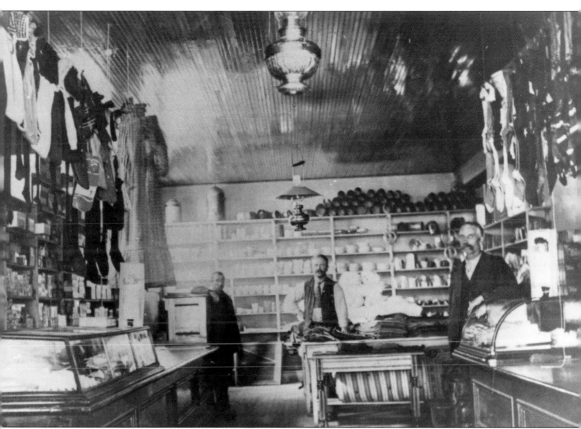

GENERAL STORE INTERIOR. This interior photograph of the dry goods general store that predated Prince McCracken's in the building now housing the Little Bear bar and restaurant shows the variety of merchandise offered by local general stores in 1900. Everything from clothing to cigars, tobacco, matches, fabric, crockery, pins, needles, dinnerware, and spittoons was available at prices hard to believe today: a five-pound bag of flour might cost as little as 12¢.

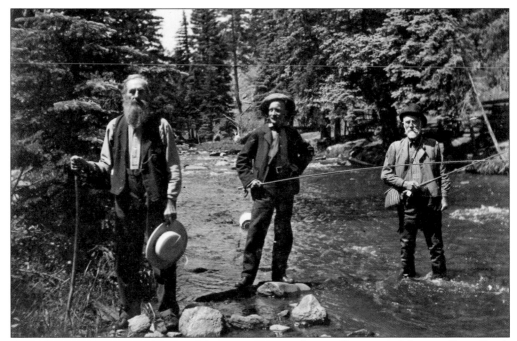

THREE NOTED FISHERMEN. Three of the men enjoying the excellent trout fishing in Bear Creek mentioned in Crofutt's *Gripsack Guide to Colorado* are Mr. Pearson, an unidentified gentleman, and local merchant Martin Luther. The note from the original Douglas family scrapbook reads, "Three Noted Fishermen."

STEWART HOTEL. Robert "Grandpa" Stewart combined an older lumberman's bunkhouse and other buildings to create the Stewart Hotel. Local old-timers recalled that he would keep his long white beard tucked inside his coat during the week and then bring it out for Sunday church services.

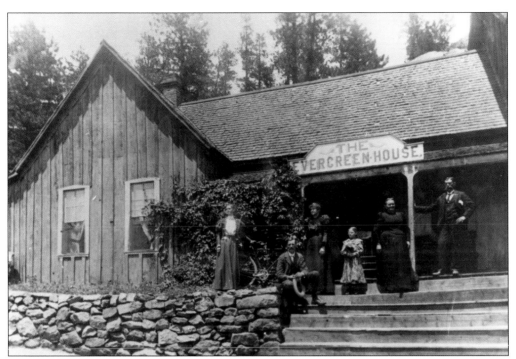

EVERGREEN HOUSE. The Evergreen House hotel was located on Evergreen's Main Street, catering to weekend tourists enjoying the fishing and hiking, or just relaxing. It was typical of the small local hotels serving the developing tourist trade in the late 1800s.

DR. JO DOUGLAS. Dr. Mary Josepha Williams Douglas, known as Dr. Jo, opened a private sanitarium on Pearl Street in Denver in 1891. Two years later, Dr. Jo purchased Evergreen property she dubbed Camp Neosho. Camp Neosho expanded into a 25-room log mansion with numerous outbuildings, now part of Hiwan Heritage Park. She died in 1938 and is remembered as one of Colorado's pioneering female physicians.

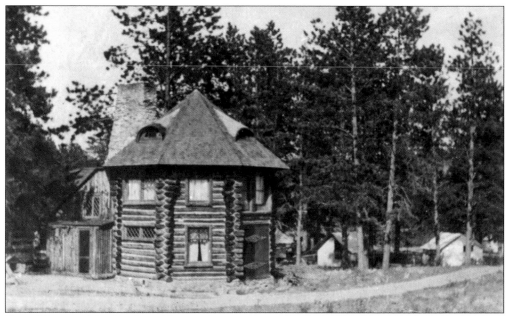

CAMP NEOSHO. After Dr. Jo and her mother, Mary Neosho Williams, purchased the former Mallett property in 1893, they hired local builder Jock Spence to convert a hay barn into a one-room cabin with a porch running the length of the building. About 1898, he enlarged the cabin by adding a two-story octagonal tower to the front. There was also an addition in back to probably house a summer kitchen and storage.

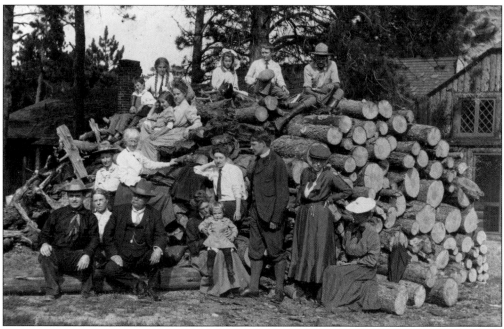

CAMP NEOSHO WOODPILE. Many of the Douglas and Williams family members gather around the Camp Neosho woodpile in this 1899 photograph. In the center is Fr. Charles Winfred Douglas in his knickers, and to his right is his mother-in-law, Mary Neosho Williams, widow of Brig. Gen. Thomas Williams, who was killed during the Civil War.

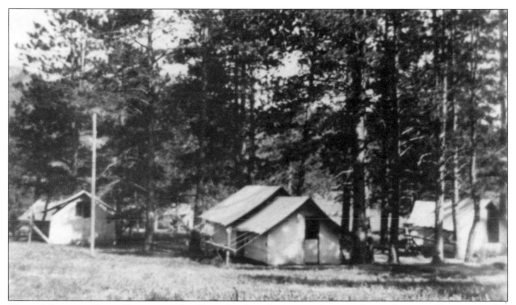

CAMP NEOSHO TENT COLONY. The Douglas family set up about a dozen large wall tents in the ponderosa pine grove at Camp Neosho to house visiting friends and family. They had wooden floors, beds, lamps, and other furniture to provide some of the comforts of home while giving the feeling of being in the great outdoors. At times, some of Dr. Jo's tubercular patients were housed in the tents. Robert Frost stayed there in 1931.

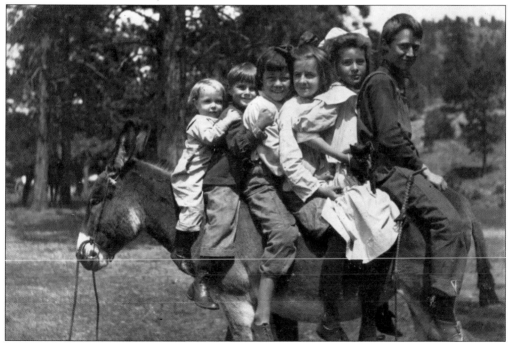

DOUGLAS FAMILY COUSINS. Loaded onto Alice, the Douglas family's incredibly patient burro, are six Douglas-Williams family cousins staying at Camp Neosho in Evergreen over the summer about 1900, including Jack Clow, Will Black, Eric Douglas, Polly Williams, Dorothy Buell, and Jack Williams.

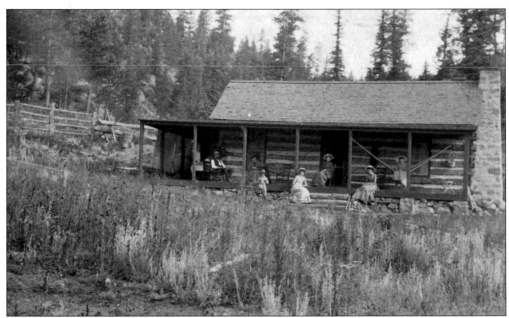

DAILEY SUMMER CABIN. John Dailey, one of the owners of the Rocky Mountain News, and his family built this small summer log cabin about 1880. This photograph is dated 1882. It is typical of the unpretentious summer homes scattered alongside Bear Creek in early Evergreen days. It has been lovingly restored and is incorporated into the beautiful Highland Haven Creekside Inn, one of the area's top bed-and-breakfasts.

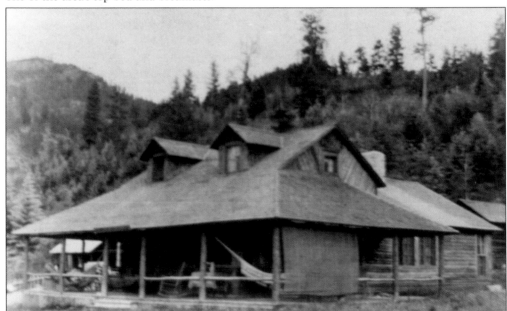

BANCROFT COTTAGE. Dr. Frederick J. Bancroft served as a Union army surgeon in the Civil War, moving to Denver shortly afterward. He became one of the region's best-known physicians, and his family built this summer home along Bear Creek. The building later became part of the Mission of the Transfiguration property and is the headquarters for Evergreen Christian Outreach, one of the area's leading charitable organizations.

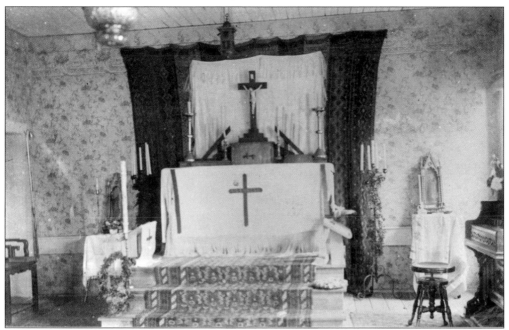

CHAPEL IN HOTEL. After the breakup of the Episcopalian St. Mark's congregation and disposal of the church building, frequent Evergreen visitors Mary Neosho Williams and her daughter Josepha (Dr. Jo) received permission from Robert Stewart to hold Episcopalian services in the Stewart Hotel dining room. This photograph shows the former St. Mark's altar and other religious furnishings that the small group of Evergreen Episcopalians used during their Sunday services.

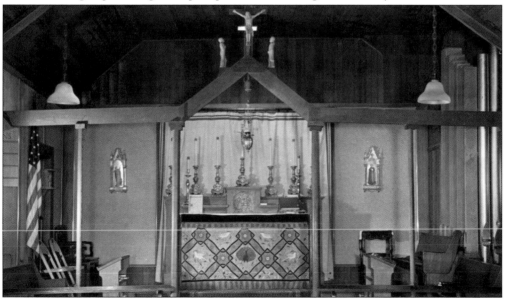

MISSION OF THE TRANSFIGURATION. After "Grandpa" Stewart's death in 1896, Dr. Jo purchased his hotel and it became a house of worship for the local Episcopalian congregation. Jock Spence remodeled the building to enlarge the church area, and clad the exterior clapboards with log siding. In 1899, it was designated the Mission of the Transfiguration by Bishop Spalding and was dedicated by him on the Feast of the Transfiguration.

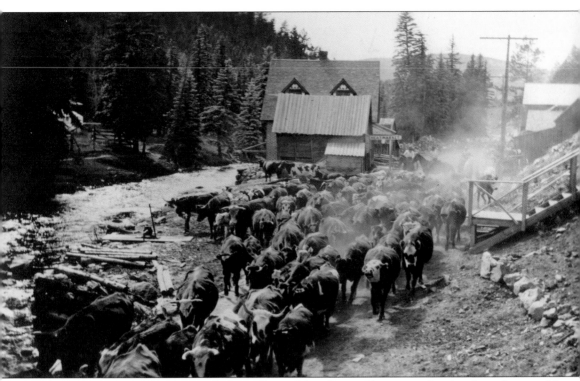

CATTLE DRIVE. There was so little traffic on Main Street, Evergreen, that local ranchers could drive their cattle directly through town and down to the rail depot in Morrison, eventually ending up at the stockyards in Denver. The buildings on the left are Westfall's meat market and the local blacksmith shop.

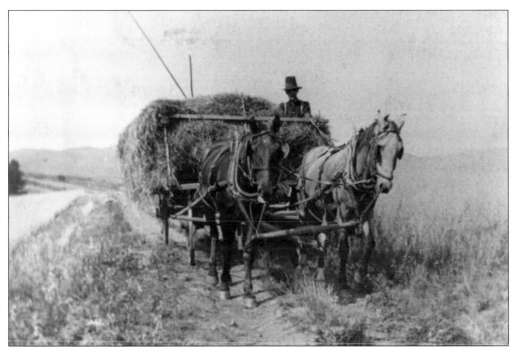

LUBIN RANCH. The rich supply of hay harvested by local ranchers is shown in this image of a hay wagon at the Lubin Ranch, located several miles southwest of Evergreen. The Evergreen area was noted for its good-quality, nourishing hay supplying food for cattle and work animals.

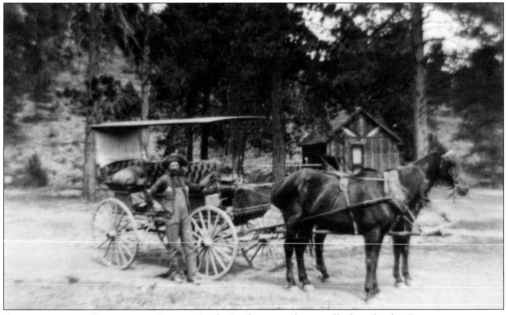

ANDY AND THE EVERGREEN STAGE. Andy Jordan stands proudly beside the Evergreen stage at Camp Neosho in this c. 1900 photograph. The stage ran from Morrison to Evergreen and was managed by the Abbo & Lewis Stage Co. The journey must have been arduous in winter in the open surrey and was downright dangerous in time of high water, when the many rickety bridges over Bear Creek were in danger of being swept away.

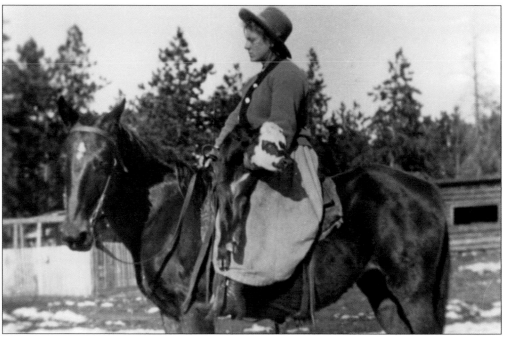

SUE BERRIEN WITH CALF. Sue Berrien, the wife of Dan Berrien of the Centaur Ranch, rescues a young calf, illustrating the tough, hard, and relentless work needed to maintain a cattle ranching operation in early 1900s Evergreen.

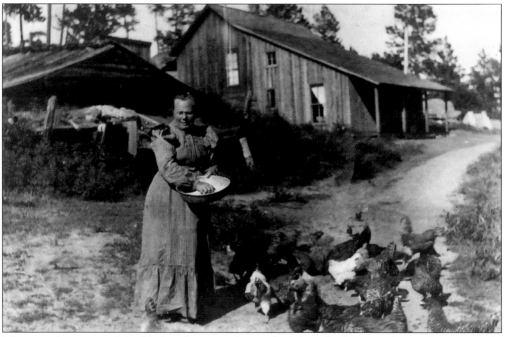

MATILDA ANDERSON. Matilda Lundgren Anderson feeds her chickens on the Anderson Ranch, giving a hint of how hard all the members of a ranching family had to work to sustain themselves and their ranching way of life. The Anderson family maintained their ranching operations for many years, branched out into other businesses, and are still very active in the Evergreen area.

Three

1900–1920

The time period of the 1910s was one of the most eventful and positive in all of Evergreen history. The driving factor was the development of the Denver Mountain Parks system, initiated in 1912 through a vote by the people of Denver. Entrepreneur John Brisben Walker was involved in pushing this decision, but Mayor Robert Speer and Denver City Council made it a reality. Famed landscape planner Frederick Law Olmsted Jr. was brought in to plan the system and to identify the most scenic properties for the city to purchase. Some properties were never intended to be developed but were secured to ensure that the scenic backdrop to the surrounding environment would remain pristine. The system was funded through an annual Denver city tax.

Prominent Denver architect Jacques Benedict and landscape architect Sacco DeBoer designed many of the Mountain Parks shelters, campgrounds, and other facilities. Acquisition of more land during the following decades created a ring of parks surrounding Evergreen and truly made it the hub of the Mountain Parks system. Genesee, O'Fallon, Corwina, Bergen, and Pence Parks are among the most well-visited facilities in the Mountain Parks system to this day.

One of the great benefits following the Mountain Parks development was the building of decent roads into the Evergreen area for the first time. Beginning in 1912, convict labor from the State of Colorado was used to construct a well-graded, graveled route from Morrison to Evergreen in order to connect Denver residents with their parks. Good roads, combined with the growing percentage of Americans who owned automobiles, meant that Evergreen became an extremely popular tourist destination.

These developments led to the first instance of a commonplace phenomenon today: commuting from Evergreen to work in Denver. Lucius Humphrey, copy editor at several Denver newspapers, commuted daily in his Model T Ford. A journey that would take perhaps 35 minutes today took Humphrey at least two hours in 1920.

Development of small electrical and water companies and of a telephone exchange meant that at least some 20th-century conveniences were available to Evergreen residents for the first time.

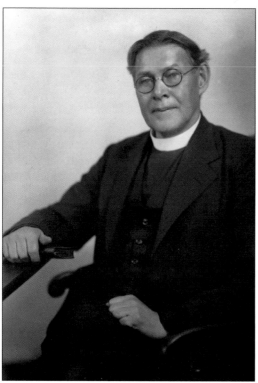

FR. CHARLES DOUGLAS. Charles Winfred Douglas, an Episcopalian clergyman, married Dr. Jo Williams in 1894 and became a beloved member of the Evergreen community. Famed for his musical expertise, his compositions are still included in Episcopalian hymnals. Besides serving on the local school board, he created a summer music school in 1907 that became part of the nationally famous Evergreen Conference held in Evergreen and in other locations until 2001.

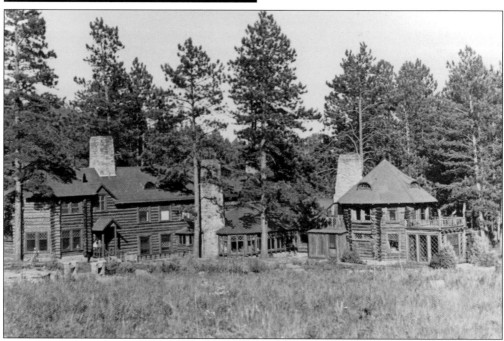

CAMP NEOSHO. By 1918, Jock Spence substantially completed the log "manor house" at Camp Neosho for the Douglas family, though a few additional rooms would be added by the Buchanan family in the early 1940s. The home would eventually include 25 rooms and is now open to the public as Hiwan Heritage Park, part of the Jefferson County Open Space parks system.

JOCK SPENCE. John "Jock" Spence was a native of Scotland's Orkney Islands. He emigrated to Canada and then to Evergreen in the 1880s, establishing himself as a master builder and stonemason. He built some of the most imposing historic structures in the Evergreen area, including Camp Neosho, Greystone Lodge, the Phelps Dodge House, the Elbert-Austin House, the Anne Evans Cottage, and many others.

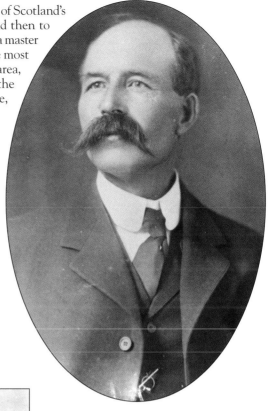

JOCK AT PHELPS DODGE RANCH. In 1907, Jock Spence began work on construction of a large log second home for wealthy newspaper publisher and politician Clarence Phelps Dodge and his wife, Regina, the niece of Governor Evans. The home is now part of the Jefferson County Outdoor Laboratory, where sixth grade and high school students spend sessions living and learning amid wild natural surroundings.

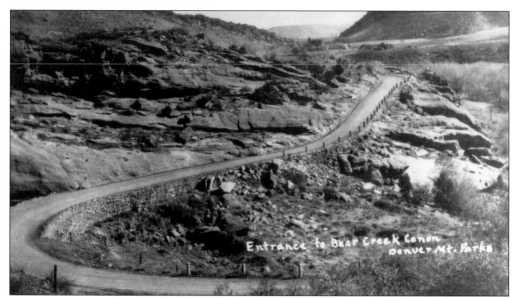

BEAR CREEK ROAD. In earliest Evergreen days, rough wagon roads led to the tiny community. That changed in 1912 with development of the Denver Mountain Parks system. Denver and state officials built a graded gravel highway to Evergreen. This transformed the whole atmosphere of Evergreen as it became a tourist destination for the general public on day trips to the Denver Mountain Parks and area resorts.

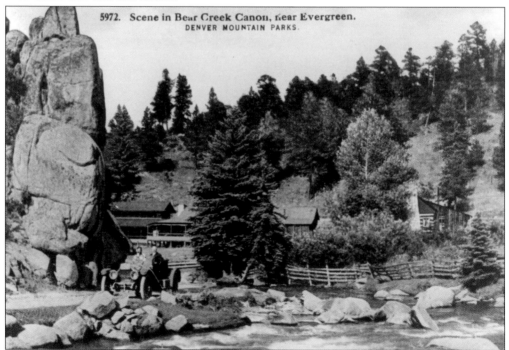

SCENE ON BEAR CREEK. This postcard view shows the bend in Bear Creek, with Sheepshead Rock overlooking the creek. In the background are the Dailey family summer cabins. Accidents while trying to negotiate the sharp turn around the rock led to installation of a mirror so motorists could see approaching cars.

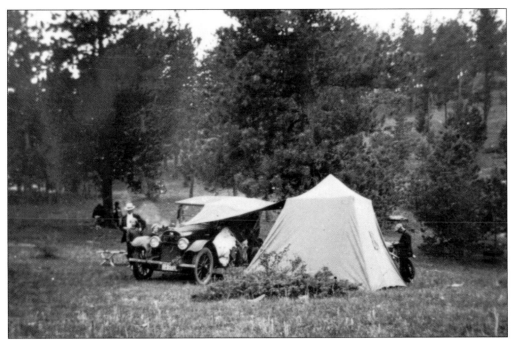

CAMPERS AT FILIUS PARK. With automobile ownership becoming more widespread, day trips or overnight car camping at the Denver Mountain Parks around Evergreen enhanced an ever larger tourist trade. Filius Park near Evergreen was one of the most popular camping spots.

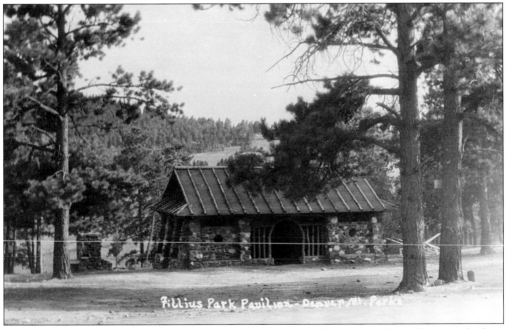

Fillius Park Pavilion - Denver Mt. Parks

FILIUS PARK SHELTER. Rustic shelters, many of them designed by Jacques Benedict, were built in the Denver Mountain Parks as the system expanded throughout the 1920s. This shelter in Filius Park near Evergreen featured ingenious bent-wood railings and has recently been beautifully renovated by Denver Mountain Parks.

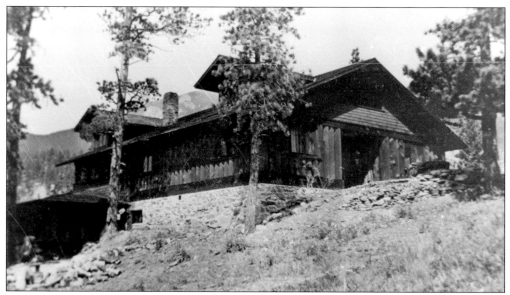

ANNE EVANS COTTAGE. Anne Evans, the daughter of Governor Evans, was an energetic patron and supporter of the arts and education in Colorado. In 1911, she hired Jock Spence to build a grand two-story "cottage" on the Evans Ranch property. The building's unique construction and interior decoration earned it an article in *House Beautiful* magazine in 1917.

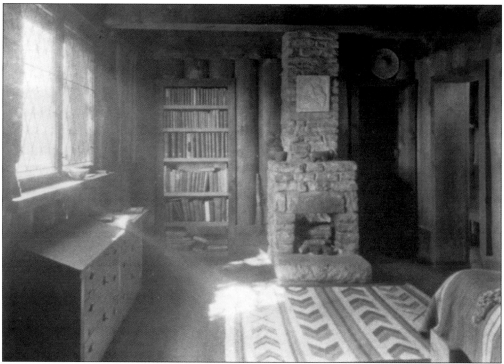

ANNE EVANS LIBRARY. The 1917 *House Beautiful* article noted that the interior of Anne Evans's cottage featured "Navajo rugs, woven in fantastic patterns of rich warm colors, Indian baskets stand about and the skins of grizzly and black bears, mountain lions, gray wolves, deer and mountain sheep serve as rugs."

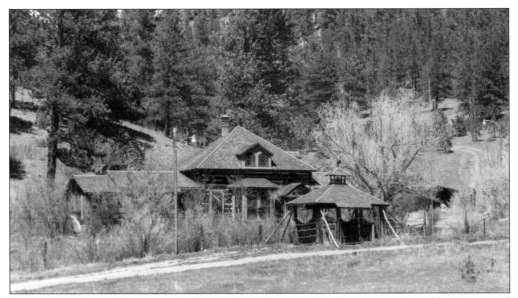

HUMPHREY HOUSE. The original 1883 J.J. Clark homestead cabin was purchased by Lucius and Hazel Humphrey in 1921. Lucius was a copy editor at two Denver newspapers and became the first commuter from Evergreen to Denver in his Model T Ford, "Mary Ann." The Humphreys' "Kinnikinnick Ranch" home was filled with mementos from around the world collected by Mrs. Humphrey and her wealthy family.

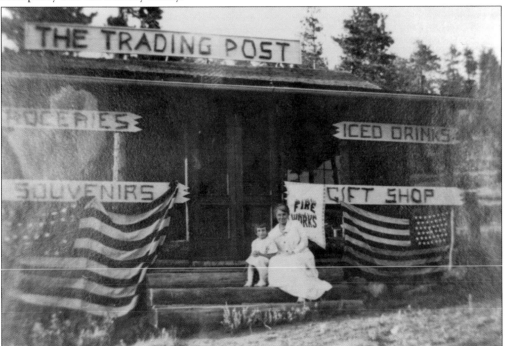

HUMPHREY TRADING POST. The Humphreys ran a trading post offering souvenirs and snacks in a little cabin at the edge of Filius Park, which was covered with tourist tents in the 1920s. Here, Hazel Humphrey and her daughter Hazel Lou pose on the steps. Little Hazel Lou's job was to crank up the phonograph at high volume to entice tourists inside.

Burros at Humphrey House. Hazel Lou Humphrey and her father pose with the family's burros, "Rye" and "Raisins," at the Humphreys' Kinnikinnick Ranch.

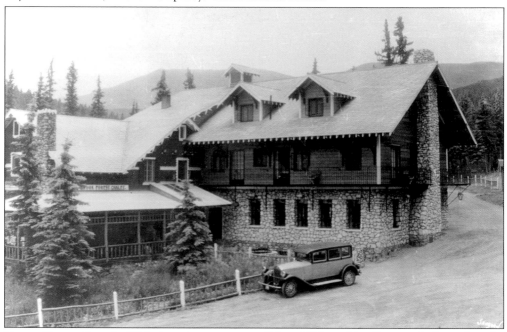

Brook Forest Inn. In 1913, Austrian immigrant Edwin Welz and his Swiss wife, Riggi, bought property near Evergreen and made road and building improvements while working at hotels in Denver. By 1919, they opened a hotel and restaurant and called it Brook Forest Inn. They added buildings to the complex over the years, including a white quartz tower.

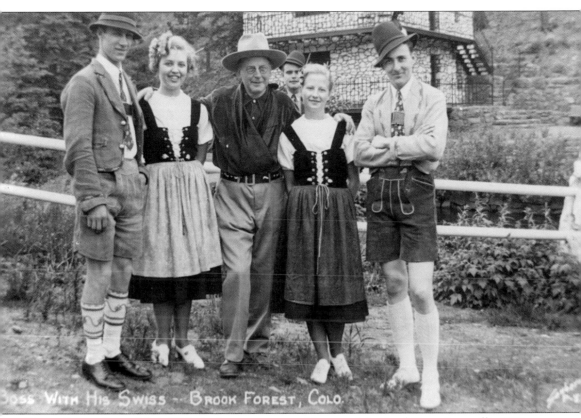

BROOK FOREST STAFF. Edwin Welz, in the center, poses with some of the Brook Forest Inn staff in 1937. He dressed them in Swiss costumes to add to the European atmosphere of the inn complex.

GENEVIEVE CHANDLER PHIPPS. Genevieve Chandler Phipps was the former wife of Lawrence C. Phipps, who served as a US senator from Colorado from 1919 to 1931. After her divorce from Phipps in 1915, Genevieve bought about 1,000 acres near Upper Bear Creek, with a view of Mount Evans. Reportedly, she and her daughters plus their maid camped out in tents on the property while the house was being built.

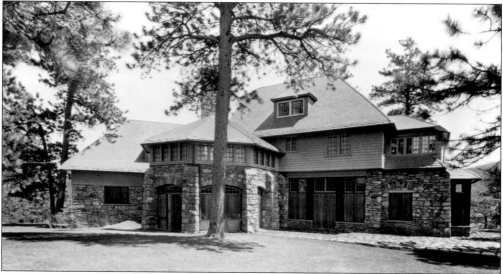

GREYSTONE LODGE. Designed by Maurice Briscoe and built by Jock Spence, Greystone Lodge near Upper Bear Creek is a magnificent example of early 1900s rustic second homes for the wealthy. The 10,000-square-foot main lodge is designed in an asymmetrical pattern that breaks up what might have been a more formal atmosphere within the home. Genevieve Phipps personally chose the exterior rocks used on the construction.

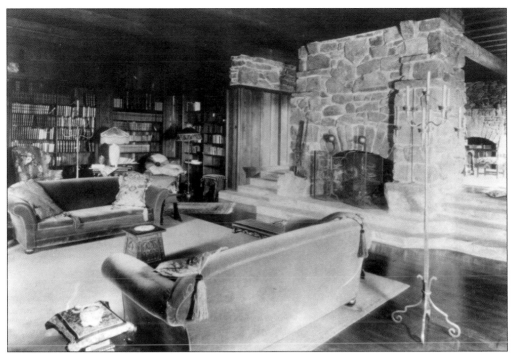

GREYSTONE LIBRARY. Jock Spence's characteristic massive stonework is seen throughout Greystone Lodge, especially in the seven fireplaces within the building.

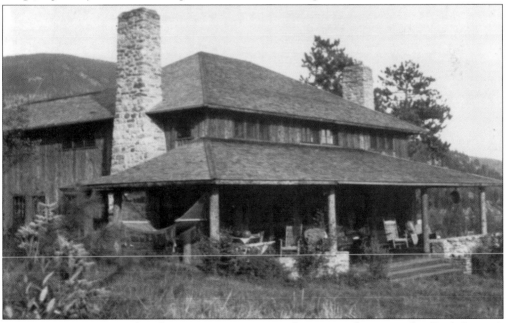

ELBERT-AUSTIN HOUSE. The Elbert-Austin House is another outstanding example of Jock Spence's workmanship. Designed by J. Christopher Jensen, it was built in 1908 on part of the original Evans-Elbert Ranch owned by Louis Elbert Everett, Governor Elbert's niece. The front porch offers a magnificent view up to the slopes of Mount Evans, while the interior boasts of wonderful custom-built woodwork. The home remains in the Austin family.

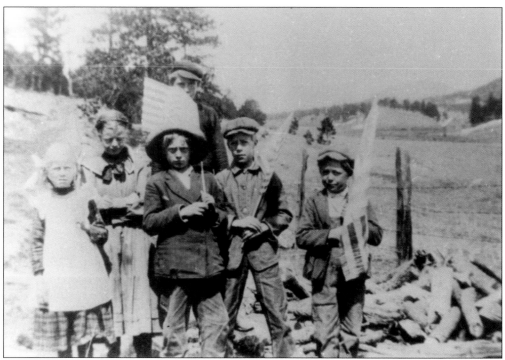

BERGEN STUDENTS, FOURTH OF JULY. The Bergen School students celebrate Independence Day in the early 1900s. The group includes Stanley Hopper, Reuben Hopper, Paul Hopper, Gertrude Olson, Clyde Hopper, and Linda Bergen.

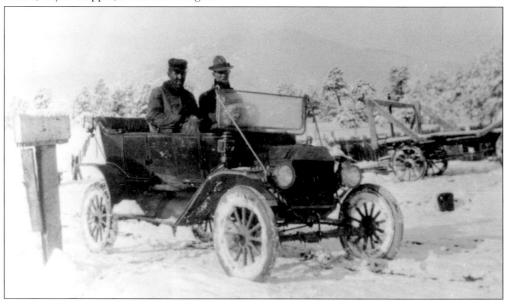

JOHNSON BROTHERS. In the early 1900s, the three Johnson brothers, George, Oscar, and Ted, acquired the former Robert Strain property and created their own ranch. The area to the west of today's Route 74 went through ownership by the Means and Noble families and is part of the Jefferson County Open Space Elk Meadow Park and Noble Meadow protected land. Here, Oscar and Ted drive their Model T at the ranch.

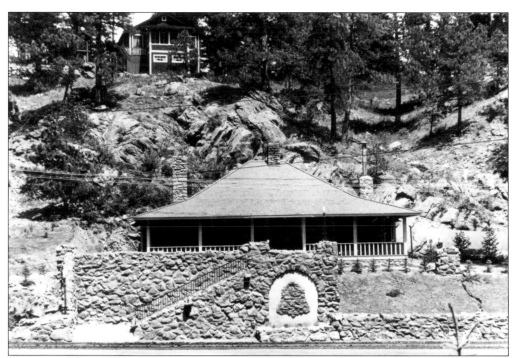

TELEPHONE EXCHANGE BUILDING. In July 1900, telephone service came to Evergreen through the Colorado Telephone Company. Eventually, Colorado Telephone merged with Bell Telephone and Tri State Telephone to form Mountain States Telephone and Telegraph Company, and Jock Spence's former home on Main Street became the telephone exchange building. The party line system lasted until the 1960s in Evergreen, when direct dialing became possible and a new telephone exchange building was constructed.

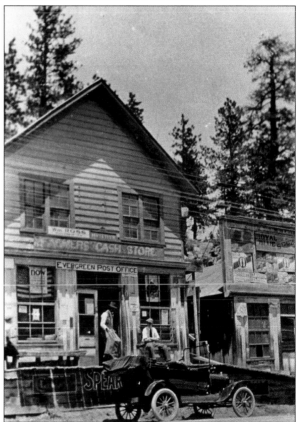

EVERGREEN POST OFFICE. The Evergreen Post Office was located in the old Martin Luther store for decades. After that, the post office was in several rented locations until a separate post office building was constructed in 1961. After another period of moves and rentals, the present Evergreen Post Office was built in 1982.

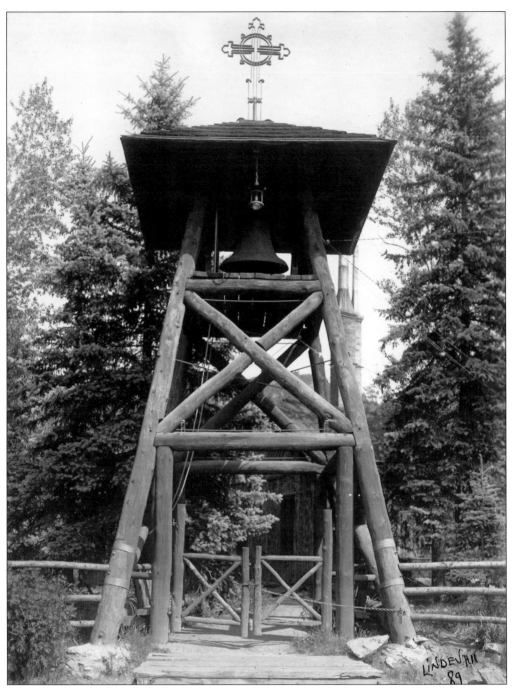

BELL TOWER. In 1911, Jock Spence built a distinctive log bell tower for the Mission of the Transfiguration, reportedly designed by Fr. Thornton B. Rennell, the Mission's vicar, and Dr. Jo Douglas. Atop the tower was a decorative metal cross from the Church of the Redeemer in New York City. The bell rang for local emergencies, such as fires and floods, and to announce church services. (Courtesy of History Colorado.)

Four

1920–1940

A wealthy automobile dealer from Lincoln, Nebraska, named Harry Sidles built a beautiful home named "Rippling Waters" along Bear Creek near Evergreen. In 1919, he formed an investment company to develop a high-quality resort hotel in Evergreen. By June 1, 1920, construction was complete at the location of the Troutdale cabins along Upper Bear Creek. Troutdale-in-the-Pines Hotel originally boasted of 100 guest rooms, plus a bar, restaurant, bakery, barbershop, and pharmacy. The hotel later expanded to include a ballroom and swimming pool, and guest capacity was enlarged to 140 rooms and 35 cabins.

Although guest registers disappeared by the time the hotel went out of business in the 1960s, Evergreen residents recall such guests as Clark Gable, Jean Harlow, Greta Garbo, the Marx Brothers, Douglas Fairbanks, Mary Pickford, and other glamorous movie stars. Thomas Transfer buses met guests at Denver's Union Station and brought them to the hotel. A small golf course was built as part of the hotel complex, later turned over to the City of Denver and enlarged. The Troutdale Hotel made Evergreen a magnet for visitors from across the country, and it became one of the nation's premier resort destinations.

Meanwhile, other area lodges and dude ranches also thrived. Brook Forest Inn, Bendemeer Lodge, Marshdale Lodge, and others were founded or expanded during the 1920s. Better roads and more auto tourism also made the development of several local summer cabin communities such as Indian Hills, Kittredge, and Starbuck (Idledale) possible, while the building of Evergreen Dam and creation of Evergreen Lake vastly expanded recreational opportunities.

Evergreen finally had its own library through the efforts of Julia Douglas, Fr. C.W. Douglas's sister. Broadening support of the Evergreen Conference summer music seminars brought hundreds to Evergreen and motivated construction of a whole new building complex.

Expansion of summer cabins in the Evergreen area motivated residents of Jefferson, Clear Creek, and Park Counties to organize the Mountain Parks Protective Association in 1925. The MPPA gave Evergreen its first firefighting organization, and members patrolled the region to check on unoccupied cabins and even the health of area trees.

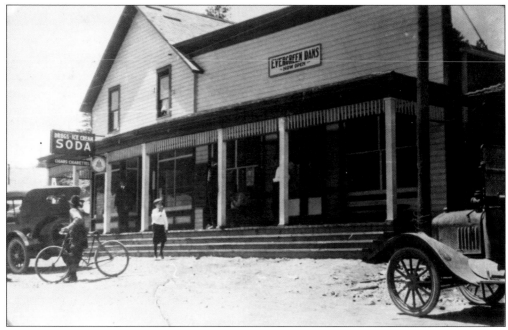

MCCRACKEN'S STORE. Prince McCracken opened his drugstore and dance hall on the site of the old Methodist church building about 1915. During Prohibition, it was reportedly one of the leading local speakeasies. McCracken also showed silent movies in the dance hall space. The building became the Roundup restaurant, then the Red Ram bar and restaurant, and then the world-famous (or infamous) Little Bear bar and music venue.

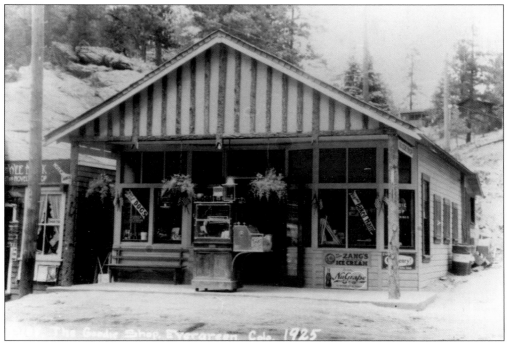

GOODIE SHOP. The Goodie Shop on Main Street, Evergreen, was one of many small souvenir and snack stores serving the increasing tourist trade during the 1920s.

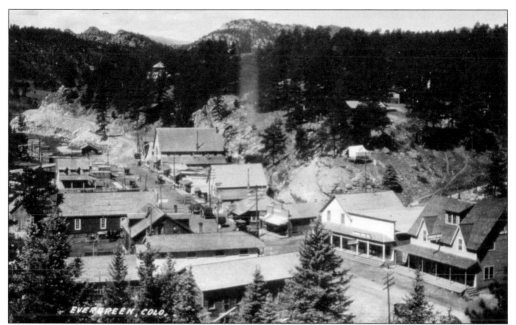

DOWNTOWN EVERGREEN. This postcard view shows downtown Evergreen in 1925. At the far end of the street stands the tall Riel general store, and opposite to that is Olde's gas station. At bottom right are Prince McCracken's drugstore and dance hall and the Evergreen Hotel, whose second floor was reportedly a brothel. The following year, Riel's store and others at the west end of town burned in a catastrophic fire.

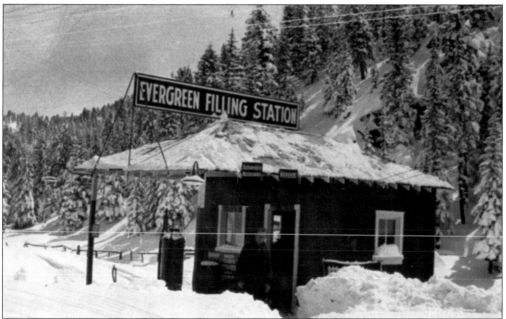

OLDE'S GAS STATION. Herman Olde established his gas station business on Main Street, Evergreen, in 1922. The gas station and garage, which moved to another location in the 1980s, is the oldest existing business in the Evergreen area. The garage is still owned and operated by the Olde family. (Courtesy of Olde's Garage.)

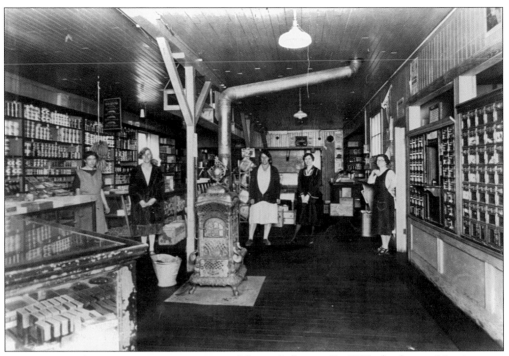

MICKEY'S STORE. By 1935, the former Martin Luther general store was owned by Andy and Nellie Mickey. The Evergreen Post Office was inside.

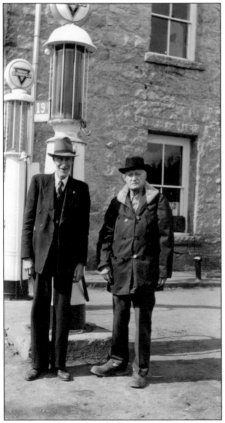

JOHN ROSS. John Ross, on the right in this photograph, was involved in timber cutting and land speculation in Evergreen. He eventually purchased much of Main Street, Evergreen, from Mary Neosho Williams. He also owned a large amount of property in nearby Morrison, Colorado. Ross placed many properties into the family trust known as the Ross-Lewis Trust, which still owns and controls many of the buildings along today's Main Street.

AFTER THE FIRE. On November 9, 1926, a fire started in the Riel general store on Main Street. Residents organized a bucket brigade, but the fire spread rapidly. A Denver fire truck took hours to reach Evergreen, and by then seven businesses and several vacant buildings were gone. By the following year the *Denver Post* reported that most structures had been rebuilt and that Evergreen was thriving. (Courtesy of History Colorado.)

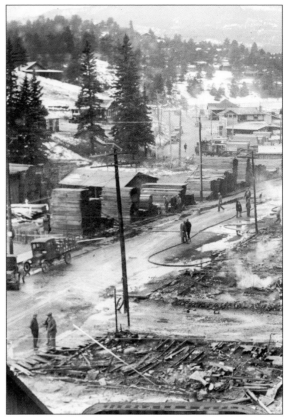

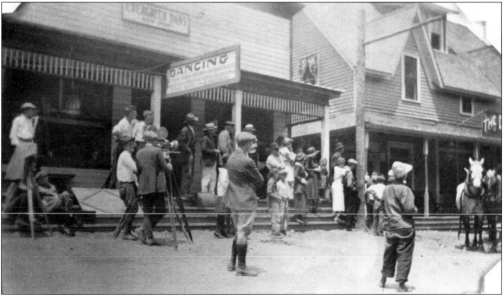

MOVIE SHOOT. Evergreen's Main Street was used as the location for several Western movie shoots in the 1920s. Here, a stagecoach has been parked in front of McCracken's drugstore and dance hall while the movie is being shot. The movie may have starred Pete Morrison, a noted cowboy movie star of the 1920s from nearby Morrison, Colorado.

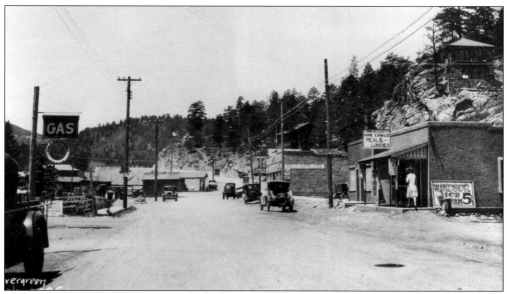

MAIN STREET, EVERGREEN. This view looking west along Evergreen's Main Street after the 1926 fire shows the rebuilt brick Riel general store in the middle distance on the right, and Olde's filling station on the left.

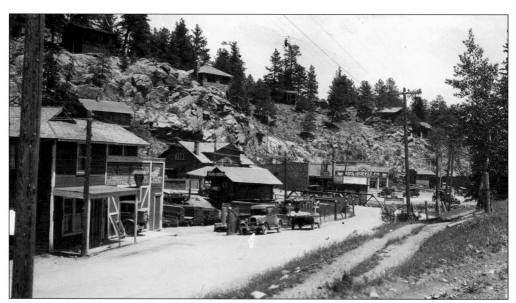

INTERSECTION VIEW. Looking along today's Route 73 toward Main Street, this view after the fire shows the Evergreen Lumber and Hardware building on the left and Riel's new brick store beyond the intersection.

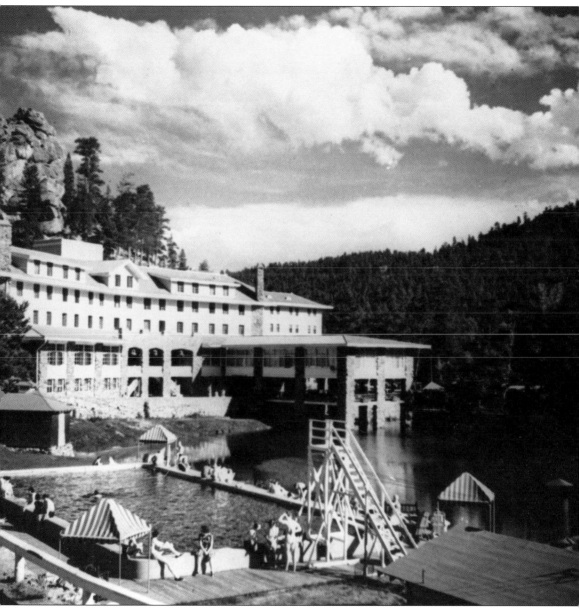

TROUTDALE-IN-THE-PINES. Harry Sidles, a Nebraska car dealer, built a magnificent hotel along Upper Bear Creek in 1920. Troutdale-in-the-Pines eventually boasted of 140 guest rooms plus 35 cabins. Movie stars such as Clark Gable, the Marx Brothers, and Mae West stayed there. Troutdale guests enjoyed a ballroom, swimming pool, bakery, pharmacy, restaurant, barbershop, and other amenities. The famed hotel became one of the top resort destinations in Colorado.

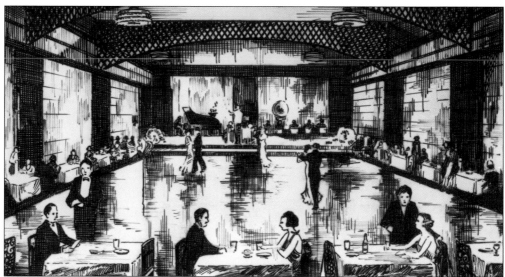

TROUTDALE BALLROOM. Troutdale's beautiful ballroom hosted some of the most famous musical groups of the big band era, including the bands of Tommy Dorsey and Denver's own Paul Whiteman.

GOLF COURSE CLUBHOUSE. A nine-hole golf course was constructed by the Troutdale Hotel company from 1923 to 1925. In 1926, the property was turned over to the City of Denver, the golf course was enlarged to 18 holes, and an octagonal clubhouse was built. The clubhouse has been enlarged many times and houses the famed Keys on the Green restaurant. (Courtesy of History Colorado.)

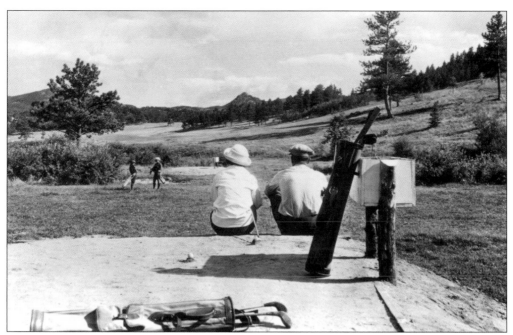

GOLFERS 1935. Golfers enjoy the beautiful view at Evergreen Golf Course in 1935.

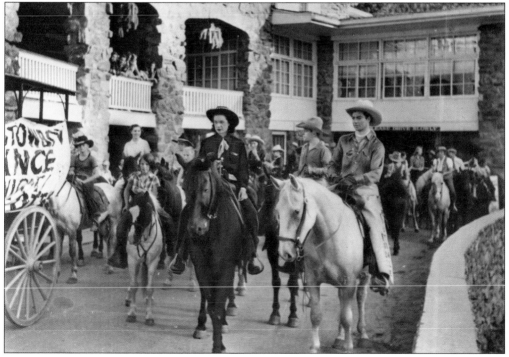

TROUTDALE RODEO. Troutdale guests such as these rode in parades through Evergreen celebrating rodeos organized by the hotel. Longtime resident Frederica "Freddie" Lincoln recalled riding in the rodeo girls' race when she was 12 against her parents' wishes. She said, "I rode in it and I won! . . . I had to sneak off to collect my prize money. It was three whole dollars—did I ever hug Sunny Jim, my horse!"

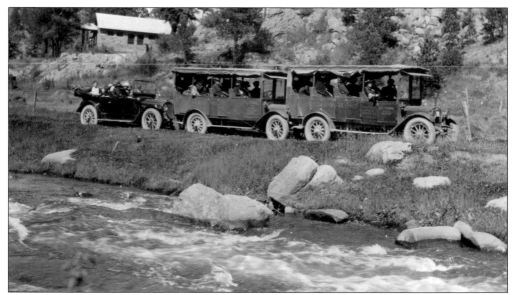

THOMAS TRANSFER BUSES. Troutdale Hotel patrons wishing transportation to Evergreen contacted the Thomas Transfer company on Wazee Street in Denver near Union Station and would be comfortably whisked to Troutdale in the company buses.

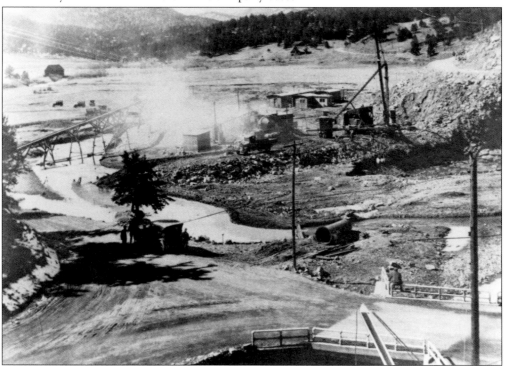

DAM CONSTRUCTION. In the 1920s, the Denver Water Board assumed ownership of the Dedisse Ranch and constructed a dam across Bear Creek for flood control. When the dam was completed in 1929, the backed-up waters created a beautiful lake that continues to offer recreational opportunities year-round. Activities are organized by Evergreen Park and Recreation District and include multiple uses of the spacious log Evergreen Lake House, built in the 1990s.

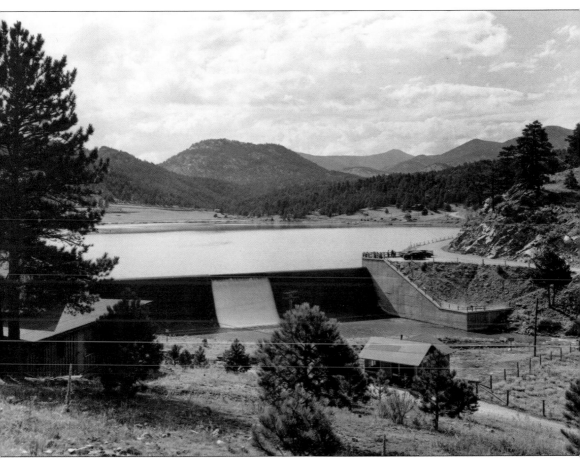

DAM AND LAKE. After water from Bear Creek was allowed in, a magnificent lake covering 55 acres of area and 35 feet deep at its deepest was created. Multiple recreation opportunities included fishing, boating, ice skating, ice fishing, and hiking and biking around the lake perimeter.

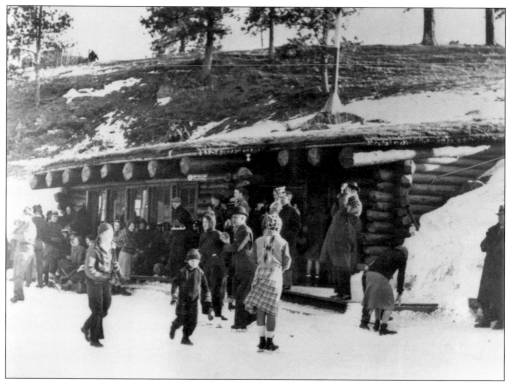

EVERGREEN LAKE WARMING HUT. Ice skating became extremely popular on Evergreen Lake after the dam completion. The warming hut, built of logs with a sod roof by Civilian Conservation Corps workers, offered food and warmth to chilly skaters. By the 1990s, after a fire, it was in poor condition and closed for years. Grants from the State Historical Fund enabled renovation, and the building now houses the Evergreen Nature Center and boat rentals.

JULIA DOUGLAS. Julia Douglas, sister of Fr. Charles W. Douglas of Camp Neosho, retired as a librarian in Newark, New Jersey, and joined her family in Evergreen. Shocked that Evergreen had no library, she requested surplus books from Newark, and in 1921 the Douglas family funded construction of a library building. After Julia's death in 1935, the library was operated by volunteers.

EVERGREEN LIBRARY. Jock Spence built the tiny stone Evergreen Library in 1921, and it remained the town library until 1971, when a new library building, now used for Jefferson County offices, was built. The old library building is now owned by the Church of the Transfiguration and is rented out as a residence.

LIBRARY INTERIOR. Display cases inside the library presented Julia's worldwide collection of dolls, given to her by Episcopalian missions or by friends who were traveling overseas. Part of the Douglas family collection of Native American artifacts was also displayed in the library. Today, these items are housed at Hiwan Heritage Park.

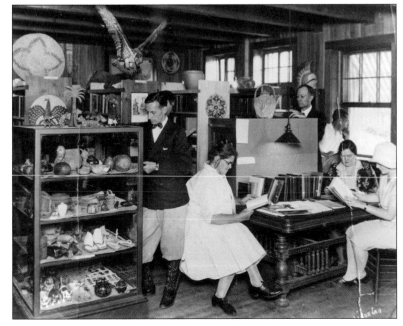

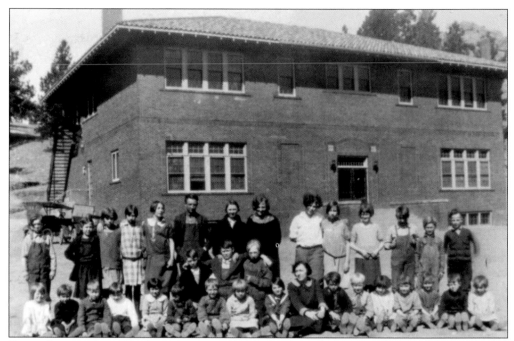

BRICK SCHOOL. In 1922, the Evergreen School Board funded construction of a modern brick school building, and many of the local one-room schools were abandoned or converted to other purposes. In the 1930s, additions were built, and high school classes were added. After construction of new local schools, the old brick school was used for county offices until its demolition in the early 1990s to make way for a new library.

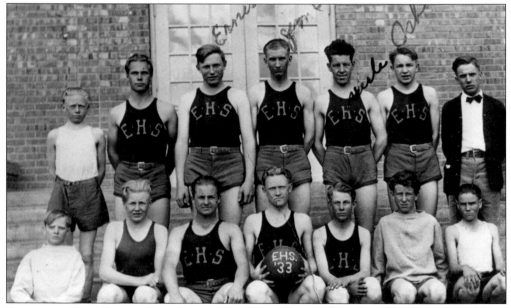

EVERGREEN HIGH SCHOOL BOYS BASKETBALL TEAM. One student, Roy Waugh, graduated from the Evergreen school at the high school level in 1931. The original graduating class of Evergreen High School in 1932 included only six students. By the following year, the high school students had increased enough that a basketball team was possible.

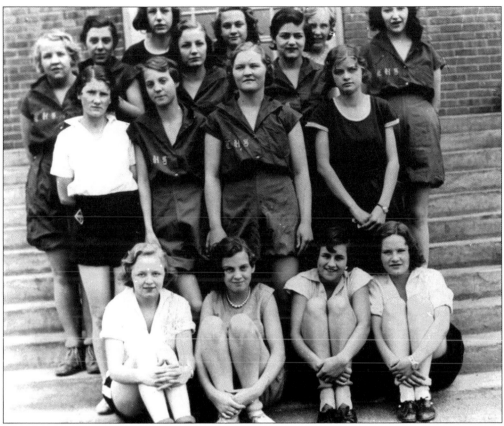

EVERGREEN HIGH SCHOOL GIRLS BASKETBALL TEAM. Evergreen High girls were just as athletically active as the boys, reflecting their Colorado mountain lifestyle. This girls team photograph probably also dates from 1933.

EVERGREEN CONFERENCE 1925. The summer Evergreen Conference continued to expand in the 1920s, with classes and retreats including choir training, organ playing, keyboard harmony, great hymns, how to encourage congregations to sing, studies in "plainsong" (Gregorian chant) and many others. In 1925, when this photograph was taken, 325 people from all across the country attended the various retreats, classes, and seminars.

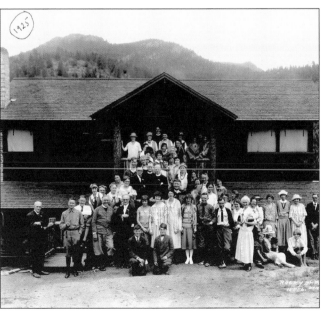

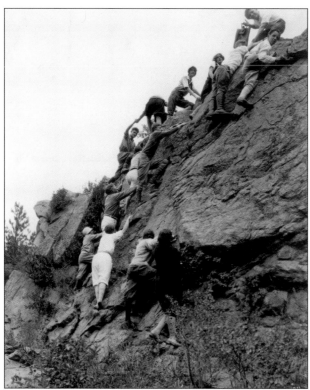

EVERGREEN CONFERENCE PARTICIPANTS. Conference participants enlivened their Evergreen visits with hiking, horseback rides, swimming, fishing, and rock climbing. The climbs were often led by the athletic Fr. Charles Winfred Douglas, who hiked and rode through much of the remote desert Southwest.

ERIC AND FREDA DOUGLAS. During the 1920s, the Douglas family held "Cow Camp Suppers" at Camp Neosho. Guests would dress in cowboy and cowgirl attire, chuckwagons were brought in, and visiting Indians would dance. Here, Eric Douglas, son of Dr. Jo and Fr. Charles Douglas, and his wife, Freda, pose in Western finery. Eric, a noted expert on Native American culture, was curator of Native Arts at the Denver Art Museum for decades.

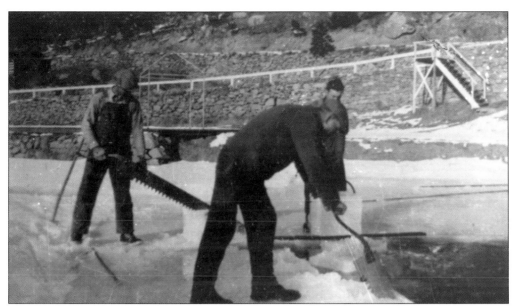

ICE CUTTING. Winter ice cutting was big business in Jefferson County before refrigerators became common in the 1940s. The ice was stored in insulated ice houses, cut into blocks, and sold door to door in the warmer months. Here, men are cutting ice from the pond at the Troutdale Hotel.

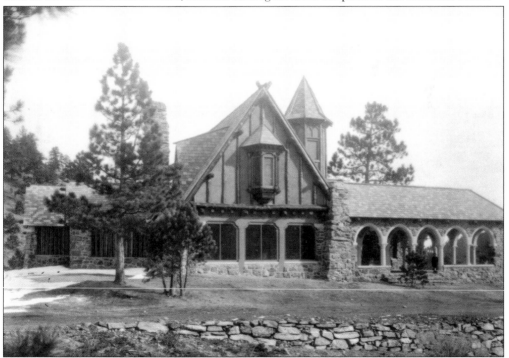

ROSEDALE. Denver architect Jacques Benedict designed a home near Upper Bear Creek for newlyweds Paul and Margery Reed Mayo in 1920. Both came from wealthy Denver families and taught at the University of Denver. Reportedly, the new home was a gift from the Reed family. After entering the US diplomatic service, Paul Mayo was posted to Peru. While there, Margery contracted a deadly disease, from which she died in 1925.

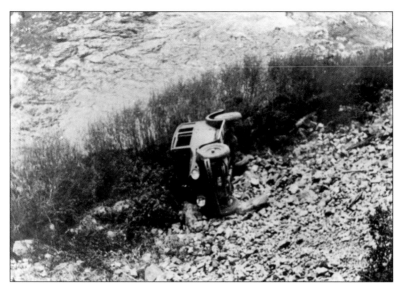

CAR IN CREEK. On September 3, 1938, a devastating Bear Creek flood caused by heavy rains ripped through Evergreen and Morrison, taking nine lives and destroying an estimated half-million dollars of property. This overturned car along Bear Creek testifies to the power of the surging water.

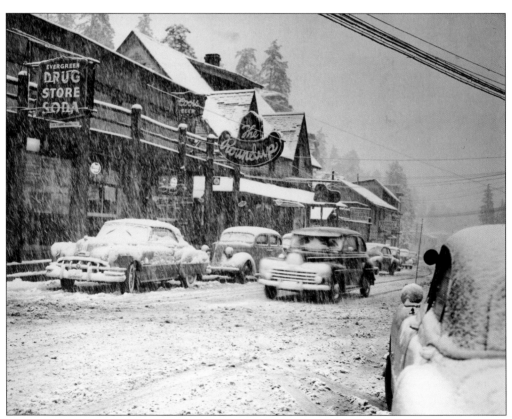

EVERGREEN SNOWSTORM. Though winter weather in Evergreen can be surprisingly temperate, the area is periodically stricken with blinding snowstorms that can pile up several feet of snow. Driving can be hazardous, as shown in this late-1930s image of Evergreen's Main Street in a snowstorm. McCracken's store was owned by the Buchanan family by then, and the former dance hall housed the Roundup restaurant. (Courtesy of History Colorado.)

Five

1940–1960

World War II brought untold suffering and death to the world during the 1940s. It also drew tens of thousands of people to Jefferson County, Colorado, to work in the nationally vital war industries in the area. The massive Denver Ordnance Plant in Lakewood employed more than 20,000 munitions workers at its height, while other local industries manufactured vehicles and ammunition. Jefferson County's population increased by 82 percent between 1940 and 1950. The population growth in the county naturally spilled over into Evergreen, and the residents numbered over 1,000 by 1950.

The war did enforce hardships on Evergreen. Gasoline rationing hit especially hard, cutting off much of the tourist trade on which the town depended. The Troutdale Hotel was forced to close for two years during the war.

In the aftermath of World War II, many of those who had served, belonging to America's "greatest generation," either returned to Evergreen or moved there to enjoy its natural beauty and expanding business opportunities. They became Evergreen's community leaders for decades, establishing the basis for growth through new services, amenities, and cultural organizations. The 1940s and 1950s saw the origins of the Evergreen Players, Evergreen Artists Association, International Bell Museum, Evergreen Volunteer Fire Department, Evergreen Ambulance Service, Alpine Rescue Team, and other organizations supporting a small but thriving community.

Even Evergreen's oldest occupation—ranching—saw a new burst of life through the establishment of ranches by families such as the Buchanans, Alderfers, Meyers, and Schoonhovens. Fox farming offered ranchers a new source of income as silver fox pelts brought top dollars in fur markets.

Hiwan Hills, the first subdivision to be built after World War II, was built on land previously part of the massive Hiwan Ranch. By 1959, Hiwan Village was the first housing development in Evergreen to offer full utilities of water, electricity and sewage service. By then, local citizens had established an Evergreen Sanitation District. A power company, known as Evergreen Public Service Company, supplied water to the community. But many Evergreen residents were still on telephone party lines until the 1960s.

DARST BUCHANAN. Oklahoma oilman Darst Buchanan and his family became acquainted with Evergreen while attending an oil industry convention at the Troutdale Hotel in 1930. They purchased the old Camp Neosho property after Dr. Jo Douglas's death in 1938, renaming and expanding it as the Hiwan Ranch. Through sale and lease, the ranch eventually covered some 30,000 acres. "Hiwan" is an Anglo-Saxon term meaning "members of a family household or religious house."

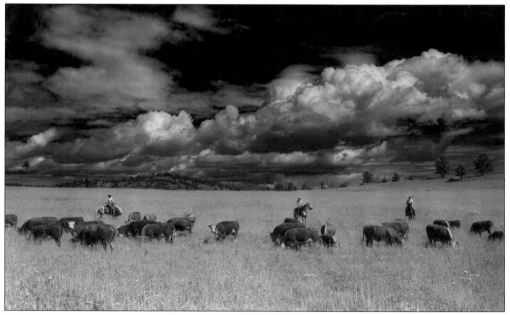

HIWAN RANCH LANDSCAPE. The Buchanans maintained a herd of about 750 prizewinning Hiwan Hereford cattle, with grazing property not only in the Evergreen area but also "down the hill" in south Denver. The Buchanans' son-in-law John Casey became the ranch manager.

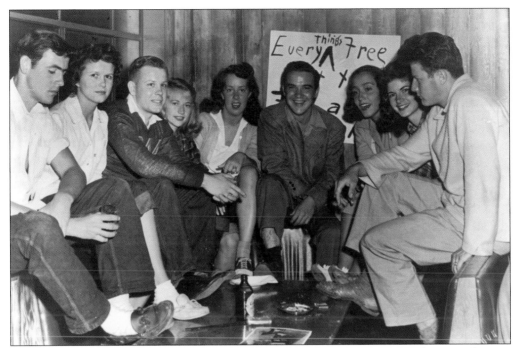

BARBARA BUCHANAN AT WARMING HUT. The warming hut at Evergreen Lake was a favorite gathering place for both Evergreen residents and out-of-towners. Here, Darst Buchanan's daughter Barbara Buchanan (second from right) and her friends gather to enjoy a festive evening.

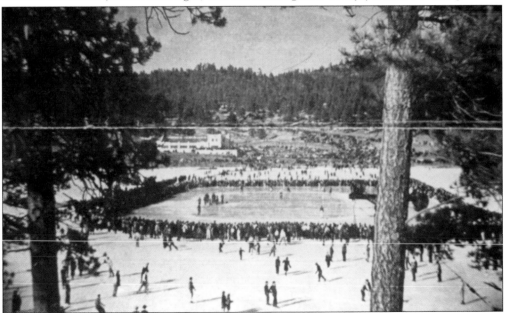

ICE CARNIVAL AT EVERGREEN LAKE. In the late 1940s, the Denver Chamber of Commerce staged a series of Evergreen events, including this February 1, 1948, Ice Carnival on Evergreen Lake. Spectators surround the 15 events presented by the Denver Figure Skating Club. The building in the background is Eddie Ott's night club, restaurant, and bar. The site is now occupied by the Lakepoint Center, housing restaurants and offices.

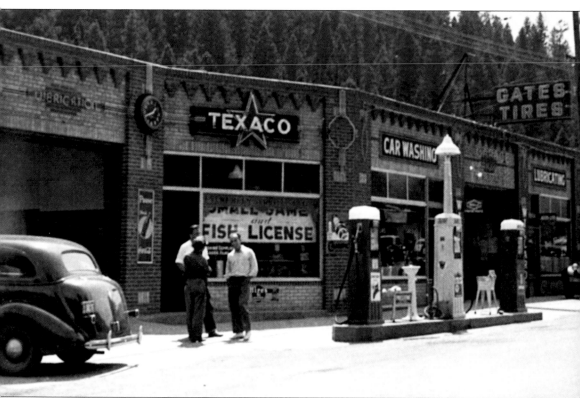

OLDE'S GARAGE AND FILLING STATION. By the 1940s, Olde's expanded far beyond its origins in one tiny building. The building on Main Street now contained a full-service garage, filling station, car wash, and tire changes and sales, plus selling fishing licenses, soft drinks, and snacks. (Courtesy of Olde's Garage.)

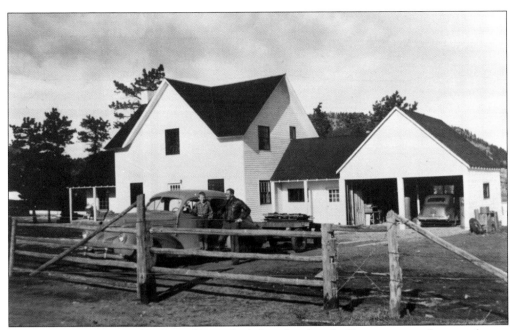

ALDERFER RANCH. E.J. Alderfer and his wife, Arleta, lived in the Evergreen area for several years before E.J. bought the former Hester and Dollison property along Buffalo Park Road the day before Christmas, 1945—without informing Arleta in advance! Both Alderfers were deeply involved in serving the Evergreen community through the PTA, Jefferson County Historical Society, Evergreen Volunteer Fire Department, and other organizations. With E.J. is his son Ben.

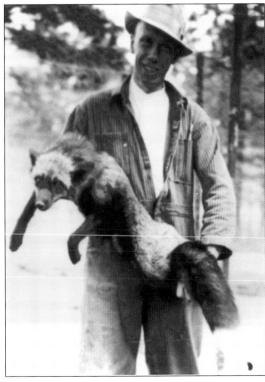

FOX FARMING. For about 20 years, fox farming was an important part of the Evergreen-area economy. Silver fox pelts were used to trim elegant clothing, and top-quality pelts were very profitable. Here, Irving Ritchie displays one of the hapless silver foxes being raised on his ranch. After World War II, competition from mink and importation of Russian fox pelts brought the fox farming era to an end in Evergreen.

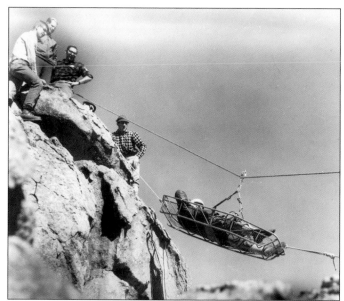

ALPINE RESCUE TEAM. After a fatal accident involving climbers in Turkey Creek Canyon, the Alpine Rescue Team was organized in 1959 on a volunteer basis, with Gordon Stucker and Dave Pratt as team leaders, supported by Evergreen fire chief "Rozzi" Clark. By 1960, the organization was incorporated. The team included about 20 men who performed rescue missions in the Colorado high country. Today, the Evergreen-based team responds to emergencies throughout Colorado.

EVERGREEN CONFERENCE ATTENDEES. Participants in the annual Evergreen Conference continued to enliven their learning experiences with rock climbing and hiking through the heyday of the conference in the 1950s and 1960s. Nationally known instructors such as organist and composer Leo Sowerby held classes of the highest musical quality.

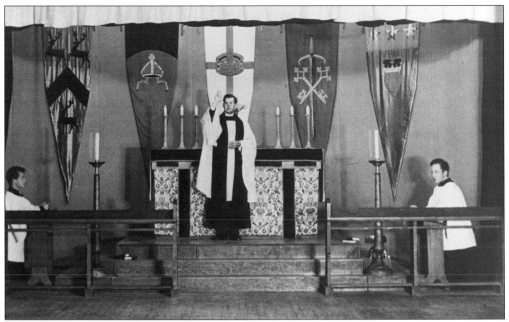

FATHER MARSH. Mordecai "Bud" Marsh became a curate at the Mission of the Transfiguration at the invitation of Fr. Charles Winfred Douglas. After ordination, Father Marsh was the vicar and then rector after the Mission became the Church of the Transfiguration in 1948. Beloved by the congregation and the community, Father Marsh served Evergreen for nearly a quarter of a century. During World War II he was the only clergyman in Evergreen.

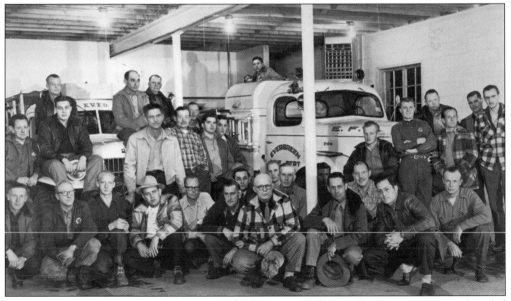

EVERGREEN VOLUNTEER FIRE DEPARTMENT. The Evergreen Volunteer Fire Department was founded by 47 people in 1948. Through a plea by Jack Rouse in power company bills, money was raised to buy the first fire truck. An Evergreen Fire District was approved in 1950, allowing purchase of more vehicles and construction of a fire station in 1952. In this c. 1952 photograph, community leader A.R. "Rozzi" Clark sits, hat in hand, to the right of the white pillar.

BEAR CREEK CEMETERY. In 1951, the present cemetery gateway was donated, as a memorial to William and Florence Ames, who died in a tragic car accident. The cemetery continued to be administered by a small volunteer committee, aided by the Evergreen Woman's Club and Evergreen Garden Club. While he was a trustee, Earl Hicks would sometimes pay for burials of needy families himself. He also mapped the entire cemetery for the first time.

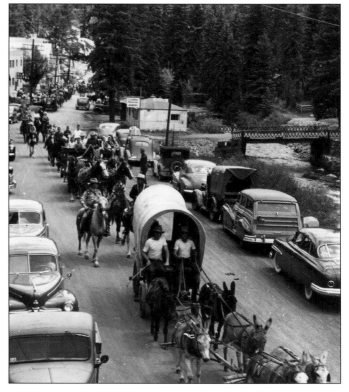

RODEO PARADE. Since the late 1940s, the annual July Rodeo Parades and Rodeos have been highlights of the summers in Evergreen, drawing thousands to the town. Spectators line the streets to see the parade pageantry with much jollification. Most organizations in the Evergreen area traditionally participate in the colorful and exciting parade.

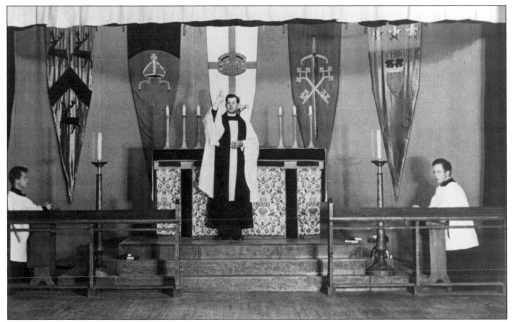

FATHER MARSH. Mordecai "Bud" Marsh became a curate at the Mission of the Transfiguration at the invitation of Fr. Charles Winfred Douglas. After ordination, Father Marsh was the vicar and then rector after the Mission became the Church of the Transfiguration in 1948. Beloved by the congregation and the community, Father Marsh served Evergreen for nearly a quarter of a century. During World War II he was the only clergyman in Evergreen.

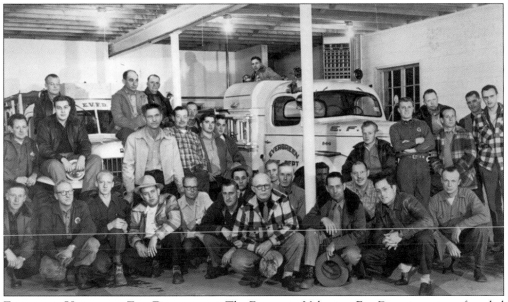

EVERGREEN VOLUNTEER FIRE DEPARTMENT. The Evergreen Volunteer Fire Department was founded by 47 people in 1948. Through a plea by Jack Rouse in power company bills, money was raised to buy the first fire truck. An Evergreen Fire District was approved in 1950, allowing purchase of more vehicles and construction of a fire station in 1952. In this c. 1952 photograph, community leader A.R. "Rozzi" Clark sits, hat in hand, to the right of the white pillar.

BEAR CREEK CEMETERY. In 1951, the present cemetery gateway was donated, as a memorial to William and Florence Ames, who died in a tragic car accident. The cemetery continued to be administered by a small volunteer committee, aided by the Evergreen Woman's Club and Evergreen Garden Club. While he was a trustee, Earl Hicks would sometimes pay for burials of needy families himself. He also mapped the entire cemetery for the first time.

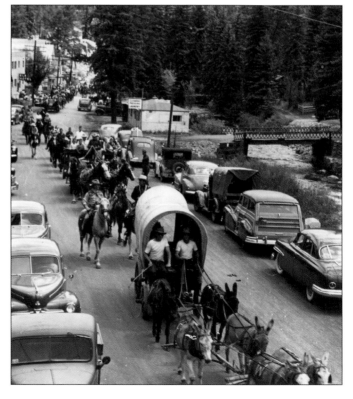

RODEO PARADE. Since the late 1940s, the annual July Rodeo Parades and Rodeos have been highlights of the summers in Evergreen, drawing thousands to the town. Spectators line the streets to see the parade pageantry with much jollification. Most organizations in the Evergreen area traditionally participate in the colorful and exciting parade.

RODEO QUEEN 1950. Pat Harper, age 18, was 1950 Evergreen Rodeo queen. Evergreen's professional rodeo history began in 1947 when the Buffalo Bill Saddle Club joined rancher Joseph Stransky to present a rodeo approved by the National Rodeo Cowboys' Association. After a hiatus in the 1950s, the rodeo reorganized as the Bear Creek Rodeo Association in 1966. The association purchased the present rodeo grounds where rodeos are held annually. (Courtesy of History Colorado.)

WALT ANDERSON. Walt Anderson, here standing beside his new Chevy about 1950, was one of the Evergreen community leaders as fire chief, one of the founders of Evergreen Kiwanis, and owner of Anderson Mountain Market, Walt Anderson Oil Company, and a gas station on Route 73. Many a local rancher had his tractor or truck towed out of marshy fields by Walt Anderson's tow truck.

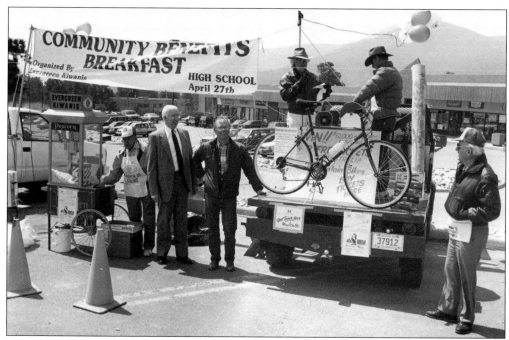

BLUE SPRUCE KIWANIS CLUB. Evergreen Kiwanis was organized in 1953 by business leaders to focus on children's medical needs and community projects. Another Evergreen club, Blue Spruce Kiwanis, was formed in 1969. Eventually, both clubs merged, and their biggest event is the annual Big Chili cook-off held to benefit local volunteer fire departments. Kiwanis is the oldest active Evergreen service club. Here, the members advertise the annual Community Benefit Breakfast in 1991.

LUTHERAN CHURCH OF THE CROSS. The Church of the Cross celebrated its 50th anniversary at its present location in Evergreen on Meadow Drive in 2014. The church is especially active in mission activities, sending parishioners to Guatemala and Uganda to help with construction and other improvement projects. (Courtesy of Jill Hansen.)

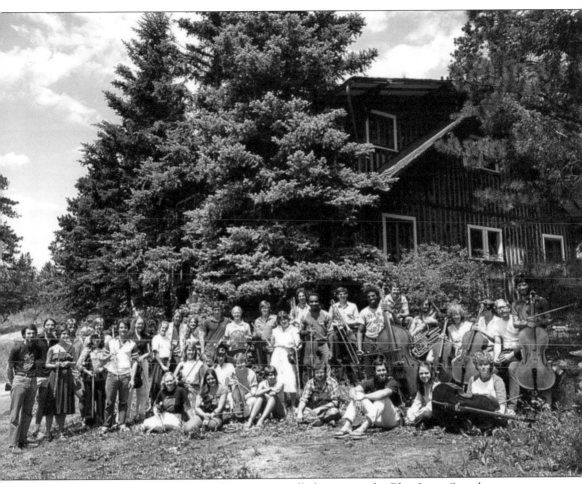

COLORADO PHILHARMONIC. The orchestra, originally known as the Blue Jeans Symphony, was organized by conductor Walter Charles in 1960 in Estes Park to create internships for young musicians. The orchestra moved to Evergreen in 1966, changed its name to Colorado Philharmonic, and purchased Marshdale Lodge in 1968 as a home base. By 1986, the orchestra relocated to Keystone Resort, changing its name to National Repertory Orchestra. (Courtesy of National Repertory Orchestra.)

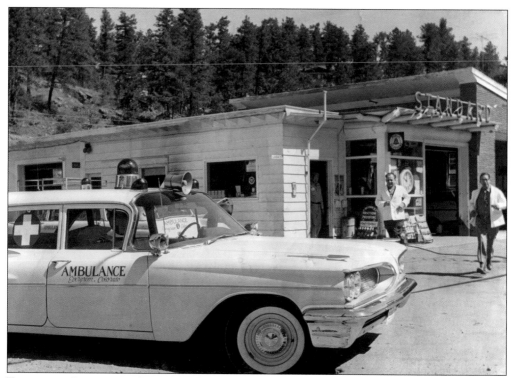

EVERGREEN AMBULANCE SERVICE. After an accident victim lay on Main Street for more than an hour before an ambulance arrived from Denver, Evergreen Ambulance Service was organized by volunteers in the early 1950s. By the 1980s, population growth demanded new facilities, and an ambulance barn was built on Route 73 through community donations and volunteer labor. The ambulance service merged with the fire department in 1987. (Courtesy of Evergreen Fire Rescue.)

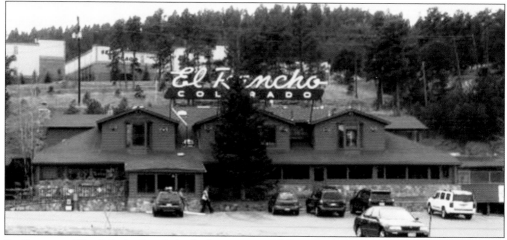

EL RANCHO. The Jahnke family built the spacious El Rancho log restaurant in 1948, using the second floor as their home. When I-70 was completed near Evergreen, El Rancho became the only restaurant in the United States with a highway exit named after it. After closing for several years and suffering water damage, El Rancho is open as a brew pub as well as restaurant under management of the Vincent family.

WILLARD AND MARY HELEN CRAIN. Willard and Mary Helen Crain were among the "new wave" of community leaders in Evergreen, moving there in 1947 from Denver. They served with the Evergreen Volunteer Fire Department, Evergreen Chamber of Commerce, Jefferson County Historical Society, and other organizations. Willard also edited the *Canyon Courier*, while Mary Helen wrote a long-term series of articles on local history that formed the basis for several books. (Courtesy of Ann Dodson.)

JACK ROUSE. Jack Rouse led nearly every aspect of community development in Evergreen in the post–World War II era. Serving as an Army staff officer gave Rouse the expertise managing the local power company and in creating a local sanitation district, organizing the Evergreen National Bank, supporting Colorado Philharmonic Orchestra, serving as president of the Evergreen Chamber of Commerce, and sustaining the community in many other ways. (Courtesy of Douglas Rouse.)

ROSS GRIMES. Ross Grimes was a true community leader. He worked to develop amenities such as the Evergreen Sanitation District, owned several businesses along Main Street, served as the fire chief, spent years planning improvement of the Route 73–74 intersection in downtown Evergreen, and served as president of the Evergreen Chamber of Commerce. He and his wife, Nancy, owned a gift shop and later casinos in Central City. (Courtesy of Ann Dodson.)

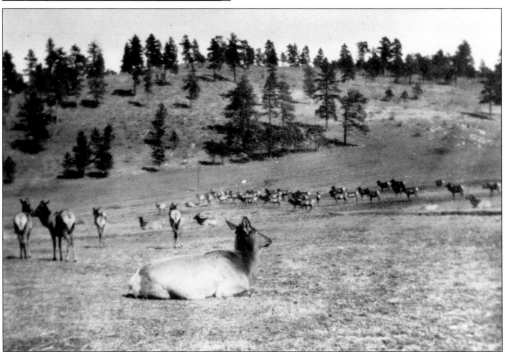

ELK HERD. Most people assume that elk are native to Evergreen. The truth is that elk are native to lower altitudes but were decimated due to hunting and development. In 1917, Colorado State Game and Fish Department transported 26 elk from Wyoming and introduced them into the Mount Evans area. Since then, they have proliferated to such an extent that they cause traffic jams in Evergreen—something local residents take in stride.

Six

1960–1980

Two of the most important developments in Evergreen history happened in the 1970s.

The first was the completion of Interstate 70 past Evergreen. Designed to stop at Denver, the highway was extended through the lobbying efforts of influential politicians and the ski industry. The completion of I-70 replaced the two-lane, winding US 40 and made the trip "down the hill" to work a matter of minutes instead of an hour or more. The highway turned Evergreen into a bedroom community and encouraged massive population and housing growth. By 1980, the US Census listed 6,736 residents, not counting those outside the Evergreen voting precinct.

The second development was the creation of the Jefferson County Open Space system through a vote of Jefferson County citizens in 1972. The postwar baby boom and G.I. Bill stimulated the growth of Jefferson County's population by 129 percent in the 1950s, added to its already enormous growth during the war years. New subdivisions sprawled into former agricultural land, creating fear that remaining open land would disappear if measures were not taken. Supported by a small percentage of county sales tax, Jefferson County Open Space supplied the answer. Just as Evergreen became the hub of the Denver Mountain Parks in the early 1900s, Evergreen became the gateway to a number of the Open Space parks, including Elk Meadow, Lair o' the Bear, Alderfer/Three Sisters, and the Hiwan Homestead Museum (now known as Hiwan Heritage Park) historic site.

In 1969, voters approved another one of Evergreen's vital institutions: the Evergreen Park and Recreation District. Led by Dick Wulf as director and guided by an elected board, EPRD eventually developed two recreation centers, extensive playing fields, and numerous parks and other facilities, besides the popular Evergreen Lake House.

Evergreen's history needed as much protection as its physical surroundings, and in 1973 a group led by Connie Fahnestock gathered to create Jefferson County Historical Society. The organization gathered a huge collection of historical photos, as well as funding education programs and exhibits at Hiwan Homestead Museum. They eventually owned and renovated the 1886 Medlen School and present education programs there.

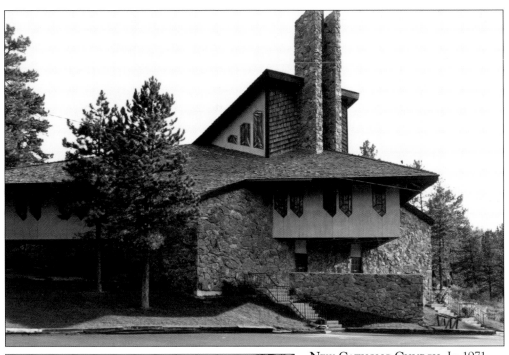

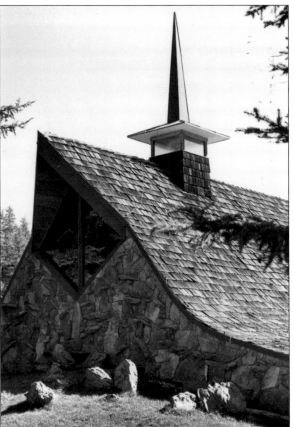

NEW CATHOLIC CHURCH. In 1971, the old church built in the 1930s was torn down to make way for a new church that would accommodate the 500 households that belonged to the congregation. Since then, the number of households in the congregation has more than doubled, and a new parish hall with spacious educational facilities opened in 2010. (Courtesy of Christ the King Catholic Church.)

NEW CHURCH OF THE TRANSFIGURATION. By the 1960s, the tiny original chapel could not hold the growing Episcopalian congregation in Evergreen. Realtor Don Shephard led a building committee that secured the necessary funding. The new church, designed by Richard Headstrom, opened in 1963. Local stonemason Brooks Morris created the custom stonework behind the altar, while wood carvings by Evergreen artist Henry Herzman were moved from the old to the new church.

HAZEL AND CATHERINE. Hazel Humphrey (left) lived at the Kinnikinnick Ranch all her life and was a beloved member of many local organizations, including the Republican Party, Jefferson County Historical Society, Eastern Star, Evergreen Woman's Club, and others. Catherine Dittman was a noted local historian, author of many historical articles and coauthor of the book *Mountain Memories.* Both were grande dames of Evergreen!

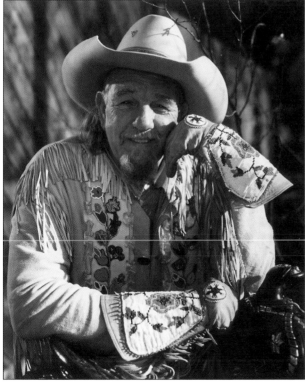

AL HUFFMAN. For decades, Al Huffman of Evergreen portrayed Buffalo Bill Cody around the world and became totally identified with the role. Al led countless parades and ceremonies, wearing reproductions of Buffalo Bill's clothing that he made himself. Al was friends with Roy Rogers and Dale Evans, John Wayne's family, Ernest Borgnine, Harry Carey Jr., and other celebrities associated with movies and tales of the Old West. (Courtesy of Linda Kirkpatrick.)

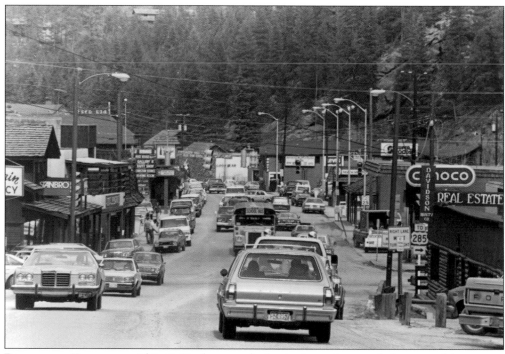

DOWNTOWN EVERGREEN. This 1960s photograph clearly shows the crowded nature of downtown Evergreen, confined between Bear Creek on one side and the sheer, rocky hillside on the other. The intersection of Route 73 and Route 74 became an especially troublesome bottleneck, alleviated in the early 2000s by a reconfiguration engineered by the Colorado Department of Transportation.

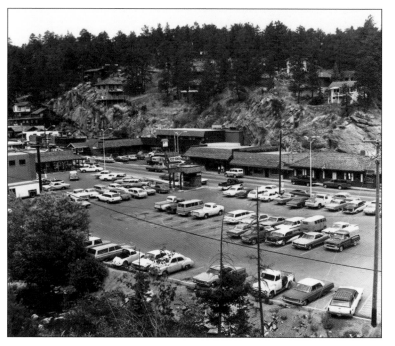

EVERGREEN 1968. Parking issues in downtown Evergreen were alleviated by the Ross-Lewis Trust when several old buildings were torn down and a parking lot was built, providing the only large area of parking in the downtown area. This paved the way (literally) for more activity along the Main Street corridor and more business expansion.

JEFFERSON COUNTY OPEN SPACE. Concern about urban sprawl led the League of Women Voters and a new group known as Plan Jeffco to initiate a ballot measure authorizing a parks system funded by a sales tax. The measure passed by a majority of voters in 1972, creating Jefferson County Open Space. The parks system now includes more than 50,000 acres of public land. (Courtesy of Jefferson County Open Space.)

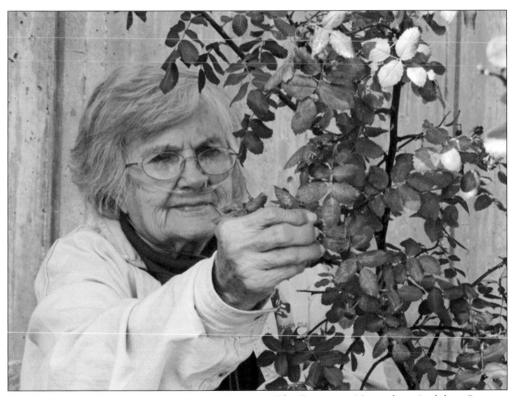

THE EVERGREEN NATURALISTS AUDUBON SOCIETY. The Evergreen Naturalists Audubon Society, now known as Evergreen Audubon, was founded in 1968 by Sylvia and Bill Brockner, Bill and Louis Mounsey, and other nature lovers. Besides traditional activities such as bird counts, the group participates in annual Earth Day events at Evergreen Lake House, and presents numerous nature-oriented programs and events. Louise Mounsey is shown trimming an Austrian Copper Rose shrub. (Courtesy of Paul Luzetski.)

EVERGREEN GARDEN CLUB. In 1965, Bill and Louise Mounsey and other avid gardeners and nature lovers founded the Evergreen Garden Club. Louise Mounsey recalled, "Our primary functions were envisioned as education and conservation." From creating and caring for one garden at the downtown highway intersection, the club has now developed, and cares for, eight public gardens beautifying the Evergreen area. Members also present programs on high-altitude gardening. (Courtesy of Paul Luzetski.)

EVERGREEN PARK AND RECREATION DISTRICT (EPRD). Gymnastics classes are among the wide range of activities offered by Evergreen Park and Recreation District. Authorized by a vote of Evergreen citizens in 1969, the district sponsored a bond issue funding construction of a recreation center near Evergreen High School later named after the district's longtime director, Dick Wulf. EPRD also manages Evergreen Lake House and Buchanan Park and Recreation Center. (Courtesy of Evergreen Park and Recreation District.)

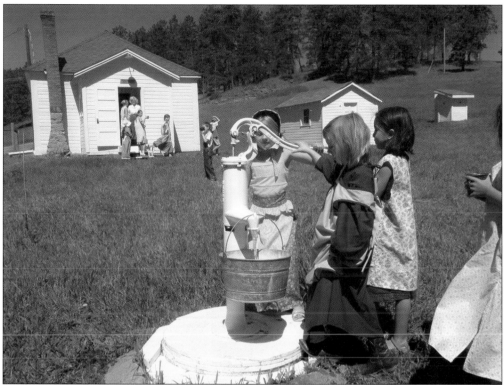

JEFFERSON COUNTY HISTORICAL SOCIETY. In 1973, a group of residents gathered to form what became Jefferson County Historical Society. The catalyst was the purchase of the former Camp Neosho/Hiwan Ranch buildings by a developer. The new historical society cooperated with Jefferson County Open Space to buy and preserve the buildings. The society also owns historic Medlen School, shown here, and presents summer education programs there for children. (Courtesy of JoAnn Dunn.)

HIWAN HOMESTEAD MUSEUM (HIWAN HERITAGE PARK). In August 1975, the former Hiwan Ranch headquarters opened as Hiwan Homestead Museum. Due to its outstanding log craftsmanship, the museum was listed in the National Register of Historic Places. Jefferson County Open Space owns and maintains the buildings, while Jefferson County Historical Society owns most artifacts and funds education programs, exhibits, and events. The museum and neighboring Heritage Grove were renamed Hiwan Heritage Park in 2016.

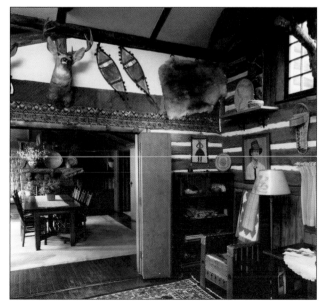

CONNIE FAHNESTOCK. Connie Fahnestock was the dynamo who energized creation of Jefferson County Historical Society, crusaded for preservation of Hiwan Homestead Museum, and became the museum's first administrator. Under her direction, museum staff and volunteers developed education programs, guided tours, other activities and events, and nominated the museum to the National Register for Historic Places. Connie was added to the Jefferson County Historical Commission Hall of Fame in 1997.

HERITAGE GROVE. The pine grove adjacent to Hiwan Homestead Museum, which once sheltered the Douglas family tent colony, was purchased by a developer in the early 1970s for condominiums. Sheila Clarke led a fundraising effort and the Evergreen community bought the grove from the developer. Heritage Grove was owned by Jefferson County Historical Society until they donated it to Jefferson County Open Space in 2010. (Courtesy of Susan Blake.)

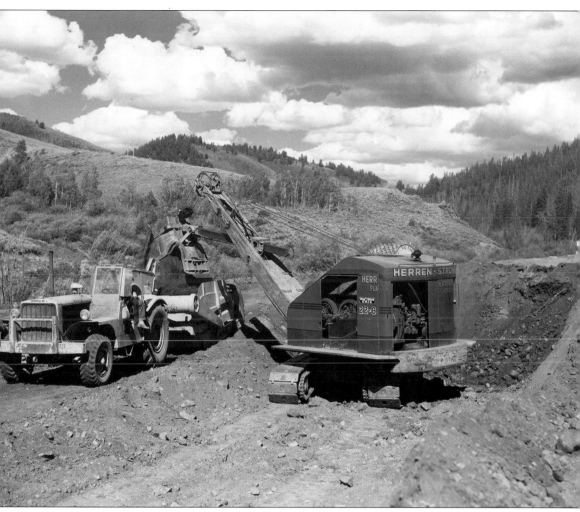

CONSTRUCTION OF I-70. Interstate 70 was originally planned to end at Denver. Lobbying by the ski industry and influential politicians such as Sen. "Big Ed" Johnson secured its extension out to western Utah. Much of its construction through mountainous areas was extremely difficult and time-consuming. Runaway truck ramps were built at strategic locations to deal with the issue of large vehicles careening out of control on mountain roads. (Courtesy of History Colorado.)

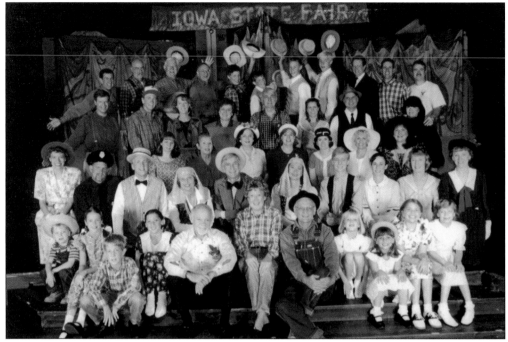

EVERGREEN CHORALE. Evergreen Chorale is one of the outstanding amateur choral groups in the United States. Beginning in 1972 with a few friends gathering to sing, the chorale now includes about 100 members and presents extremely professional concerts and musicals. The chorale has been responsible for developing Center Stage as Evergreen's premier performing arts venue through many improvements, and they have performed in Europe several times. (Courtesy of Evergreen Chorale.)

EVERGREEN ELKS CLUB. Formed in 1967, the Evergreen Elks Club purchased a former bowling alley and transformed it into their meeting place, and one of the largest events venues in Evergreen. Besides membership gatherings such as the crawfish boil shown here, the Elks organize many events to benefit local charities and to honor those who served in the military. Other organizations such as the Evergreen Jazz Festival also use the Elks Lodge.

SYLVIA AND BILL BROCKNER. Bill and Sylvia Brockner moved to Evergreen in 1965 from New York, where both had been active naturalists and conservationists. Besides their involvement in organizing and sustaining the Evergreen Naturalists Audubon Society, Sylvia has written a long-standing series on nature topics for the *Canyon Courier* newspaper. (Courtesy of Sylvia Graovac.)

EVERGREEN ROTARY CLUB. Evergreen Rotary, chartered in 1985, is one of Evergreen's most active service organizations. Re-roofing and renovating the home that became Seniors' Resource Center was one of the club's early efforts. The spacious lobby and art gallery at Center Stage, and the pavilion at Hiwan Heritage Park, are among many improvements funded by Rotary. In this photograph, Rotary members repair the porch at Seniors' Resource Center.

ALDERFER SAWMILL. During the beetle kill epidemic of the 1970s, Hank Alderfer established a sawmill and through his Front Range Lumber company was permitted to harvest beetle kill lumber from Denver Mountain Parks property. With Hank's typical energy, he sold an estimated five million board feet of lumber before a zoning dispute with Jefferson County forced him to end his lumber operation. (Courtesy of Hank Alderfer.)

HANK AND BARBIE ALDERFER. Hank and Barbie Alderfer are two of Evergreen's most beloved citizens. Hank served on the boards of Jefferson County Historical Society, Mountain Area Land Trust, Evergreen Park and Recreation District, Bear Creek Cemetery Association, and Evergreen Community Plan, and wrote historical articles for the *Canyon Courier* included in his book *Yesteryear*. Hank was inducted into the Jefferson County Hall of Fame in 2007. (Courtesy of Hank Alderfer.)

TOM HAYDEN AT SAWMILL. Tom Hayden, great-grandson of territorial governor John Evans, took advantage of the 1970s beetle kill epidemic to found a sawmill on family land, establishing Hayden Forest Products. Tom milled quality paneling and specialty lumber as well as firewood, using his expertise in operating and repairing heavy machinery. Tom's sawmill was the last in a long line of area lumber mills when it closed in 2003. (Courtesy of Elaine Hayden.)

TOM AND ELAINE HAYDEN. Tom and Elaine Hayden's support for Evergreen include Tom's service with Evergreen Fire Rescue as firefighter, president of the board and arson inspector, and Elaine's tenure as president of Jefferson County Historical Society and on the cemetery board. Tom used his musical talents collaborating with Hank Alderfer on history programs called Armchair Adventures. He served as Clear Creek County commissioner before his death in 2016. (Courtesy of Elaine Hayden.)

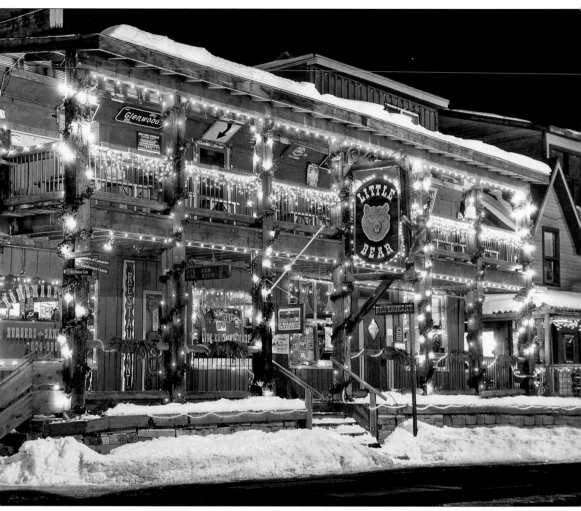

LITTLE BEAR SALOON. The current Little Bear building was a general store, drugstore and dance hall, restaurant, Red Ram bar, and finally the Little Bear Saloon in 1975. Though known as a biker bar, the Little Bear's greatest fame comes from its quality musical acts. The interior is filled with music posters, license plates from around the planet, and the famous collection of bras hanging from the stage. (Courtesy of Craig Patterson.)

CAROL AND JACK NEWKIRK. In the 1960s, the hydrocephalic condition of Carol and Jack Newkirk's baby daughter Victoria was cured by Jack's design of a new type of shunt. Moving to Evergreen in 1970, Carol and Jack led a company, Denver Biomaterials, Inc., manufacturing sophisticated shunts for various medical conditions. After selling their operation to Johnson and Johnson, the Newkirks developed an advanced surgical tool, which was also successful. (Courtesy of Christina Seldomridge.)

WILMOT ELEMENTARY SCHOOL. Named after rancher Dwight Wilmot, whose family named Evergreen and whose home survives nearby, Wilmot Elementary School was built in 1962 and enlarged several years later. The school is proud of its WISE (Wilmot Instructional System for Enrichment) program, which involves students in problem solving, language arts, computer use, Audubon Club, and drama. Here, Jonathan Cross shows off his geodesic dome as part of the "Shelter 1988" student projects.

97

NEW EVERGREEN HIGH SCHOOL. Replacing the old brick school and several makeshift buildings, the new Evergreen High School building opened in 1970. The school mascot is the Cougar, and the school colors are blue and gold. Evergreen High has won the National Blue Ribbon School Award twice. Of those who graduate, 95 percent go on to college. In this photograph, Patty Faber blocks a shot in 1986 as the Cougars win over Alameda 59-47.

SENIORS' RESOURCE CENTER. Jefferson County created Seniors' Resource Center, with branches in Evergreen and other locations, in the 1970s. The organization acquired the old Berrien/Jarvis home, known as the "Yellow House," in 1985. Evergreen Rotary Club and others helped with renovation, and today Seniors' Resource Center offers many forms of assistance, meals, and all kinds of activities, serving nearly 25,000 people annually. Here, director John Sabawa serves ice cream to seniors in 1982.

Seven

1980–1990

By 1984, the estimated local population was 18,120. By 1990, it was 23,600. Such explosive growth created anxiety about preserving Evergreen's unique mountain ambience. In the absence of a city government, mayor, city council, and other trappings of incorporated communities, Evergreen citizens turned local issues into opportunities, cooperating with a broad range of County and State agencies to find solutions.

Development of The Ridge, Tanoa, and other new upscale subdivisions created divisions between residents of "old" Evergreen clustered around the downtown area, and new subdivisions closer to I-70. This situation mirrored the former division between the local ranching and farming families, and the summer cabin visitors.

Several community groups were formed to discuss the most practical balance between development and preservation. Among them were the Mountain Area Planning Council, the Evergreen North Area Balanced Land-Use Effort (ENABLE), and the Evergreen Design Task Force.

Finally, in 1983 a group of 18 people was selected to create an Evergreen Community Plan, approved and published in 1987. With the participation of Jefferson County Planning and Zoning department as well as community groups and citizens, the plan laid out recommendations for development, design guidelines for new construction, suggestions for cooperation among the various public lands administrators, and preservation of historic buildings and valuable scenic areas. Though the plan lacked a solid basis for enforcement of its guidelines, much development in Evergreen was forestalled anyway by the statewide economic recession of the mid-1980s.

New organizations sprang up in the 1980s to serve the growing population. Mount Evans Hospice was formed in 1980 by volunteers and now offers a wide range of services for the terminally ill and other populations in need of help. Evergreen Christian Outreach (ECHO) also started on a volunteer basis in 1987 and is now one of Evergreen's most prominent charities serving the underprivileged.

Evergreen's cultural scene expanded through the formation of the Evergreen Chamber Orchestra in 1983, with Dr. William Morse serving as the first director. After being based at Rockland Community Church for many years, the volunteer orchestra presents outstanding concerts in several venues around Evergreen and in Littleton.

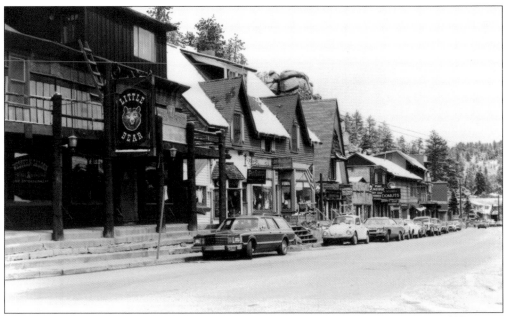

MAIN STREET. By the 1980s, many Main Street buildings had been renovated and the old business district was thriving. In the foreground of this photograph, the Little Bear Saloon and restaurant gained a worldwide reputation for its quality musical performances, and the ground floor of the former Evergreen Hotel is filled with the Potpourri used clothing and antique shop.

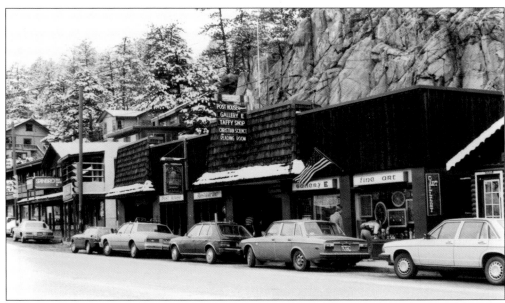

DOWNTOWN EVERGREEN. Evergreen became known in the 1980s for its continuing tradition of quality art galleries. Also shown in this photograph are the extremely popular Post House restaurant and the Stanbro realty office at left, and the longtime Davidson insurance office on the right.

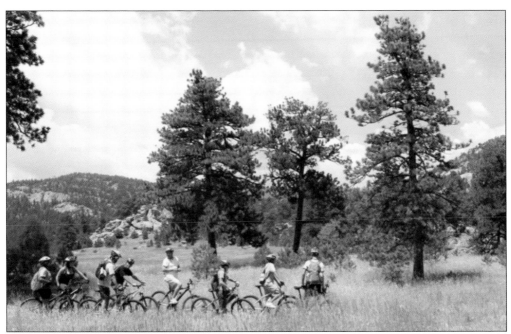

ALDERFER THREE SISTERS PARK. In 1986, Alderfer/Three Sisters Park was added to the Jefferson County Open Space parks system through the generosity of the Alderfer family. The Alderfer Ranch House and barn are managed by Evergreen Parks and Recreation District, while 15 miles of trails have been built and are maintained by Jefferson County Open Space. The Three Sisters are rock formations in the park. (Courtesy of Jefferson County Open Space.)

MOUNTAIN RENDEZVOUS. For 20 years, Jefferson County Historical Society organized the annual Mountain Rendezvous in Heritage Grove during the summer. The Rendezvous was a showcase and fundraiser for local nonprofit organizations, as well as a Fur Trade encampment illustrating the lives and times of the Mountain Men. Live music, children's games, and races enlivened the event. The last Mountain Rendezvous was held in 1995.

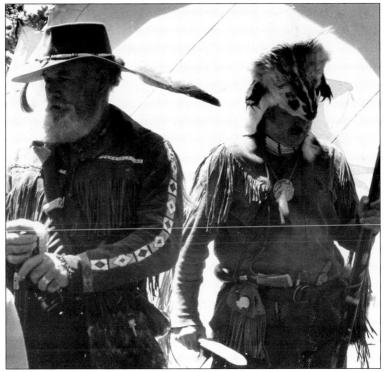

Summerfest. The third big summer event held in Heritage Grove, along with the Mountain Rendezvous and Fine Arts Festival, was the Summerfest. Now held in Buchanan Park, this is a lively arts and crafts festival with continuous music and entertainment, food booths, and activities for children. The event is sponsored by the Center for the Arts Evergreen. (Courtesy of Center for the Arts Evergreen.)

Evergreen Woman's Club. Shirley Yetter speaks to the Evergreen Woman's Club on its 50th anniversary in 1988. The Woman's Club was the oldest nonprofit organization in Evergreen, contributing to countless community initiatives over the years. They included Alpine Rescue Team, Mount Evans Hospice, Seniors' Resource Center, Buffalo Park School restoration, preservation of Heritage Grove, and many other projects. Unfortunately, the club disbanded in the early 2000s due to declining membership.

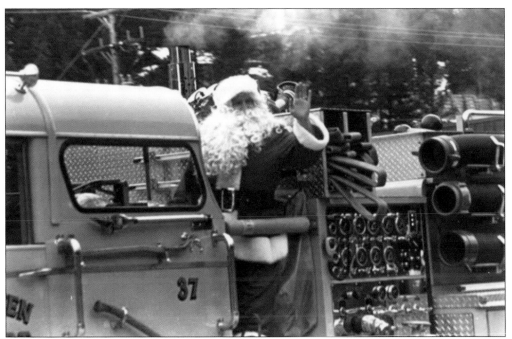

HOLIDAY WALK. The Evergreen Downtown Business Association (EDBA) sponsors the Evergreen Holiday Walk annually on the first weekend in December. Santa arrives at the Lake House on a fire truck, the Evergreen Christmas tree is lit, and Main Street is closed so that Santa, Mrs. Claus, musical groups, and downtown businesses can entertain visitors. Shuttle buses transport visitors to and from various points around town.

HIWAN HOMESTEAD MUSEUM SCHOOL PROGRAMS. After the museum opened in 1975, several lively hands-on education programs were developed, mostly for fourth-grade elementary school students to coincide with the school district curriculum. Later, programs for third grade and home school groups were added. Thousands of schoolchildren visit the museum during the school year to participate, and in the summer a day camp called Discovery Days draws still more children to the museum.

CAROL LINKE AND MOUNT EVANS HOSPICE. In 1980, a group of volunteers gathered to discuss creating an organization to assist the terminally ill. At first, they met in founder Carol Linke's basement, and she became the group's first director. Over the years, the organization has obtained Medicare and Medicaid certification and now offers a wide range of services. Mount Evans Hospice also conducts a summer camp for bereaved children called Camp Comfort. (Courtesy of Linda Kirkpatrick.)

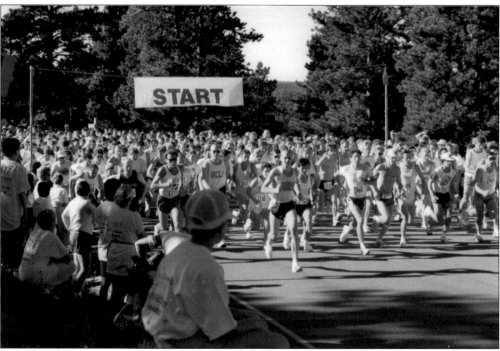

FREEDOM RUN 1991. The 5K Freedom Run has been held every year in Evergreen on the Fourth of July since 1981 to benefit Mount Evans Hospice. It is one of the biggest and most popular events held in the area. (Courtesy of Linda Kirkpatrick.)

MIKE AND ANNE MOORE.
Here, Mike and Anne Moore play and yodel to encourage participants in the Freedom Run. After developing and successfully marketing a baby carrier called the Snugli, they showed deep commitment to the Evergreen community. Their activities include service on the Open Space Advisory Committee, Environmental Defense Fund Advisory Board, performing with the Evergreen Chorale, and forming their own family musical group known as the Baroque Folk. (Courtesy of Linda Kirkpatrick.)

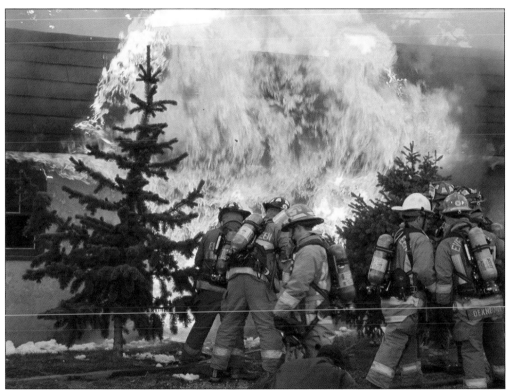

EVERGREEN FIRE RESCUE. From its tiny origins in 1948, Evergreen Volunteer Fire Department grew steadily, merged with Evergreen Ambulance Service in 1986, and is now known as Evergreen Fire Rescue with eight modern fire stations using the most advanced vehicles and equipment. (Courtesy of Evergreen Fire Rescue.)

TONY GRAMPSAS. After Tony Grampsas and his family moved to Evergreen, he was elected to the Colorado House of Representatives, then to the Colorado State Senate. Popular among his fellow legislators and constituents, he was the first official elected to state office from Jefferson County's mountain area. Evergreen residents were especially grateful for his support of replacing the dangerous, winding two-lane route to Evergreen with the new, four-lane Highway 74.

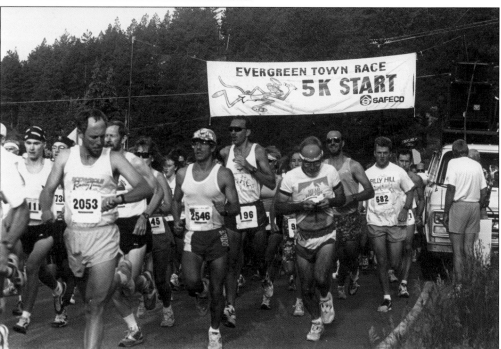

EVERGREEN TOWN RACE. The Evergreen Town Race originated in 1978 and offers both 5K and 10K routes winding down Upper Bear Creek Road past the beautiful mountain scenery and ending at Evergreen Lake. The race benefits the Alpine Rescue Team and is held annually in early August. In 1998, Jason Hubbard ran the fastest Colorado 5K time ever in the Evergreen Town Race.

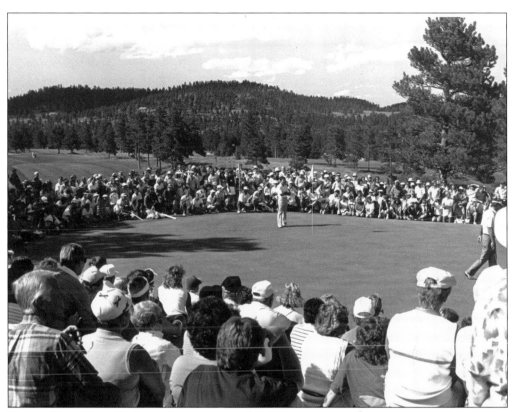

HIWAN GOLF CLUB. In the early 1960s, former Hiwan Ranch land was divided to make room for over 300 upscale homes, a country club, and a golf course. The development drew praise for its design qualities, skillfully blending into the Evergreen landscape. From 1965 to 1992, a golf tournament known as the Hiwan Colorado Open Golf Tournament and then the Coors Colorado Open drew tens of thousands to the Evergreen area.

WINSTON JONES. Winston Jones worked as a Hollywood makeup expert before moving to his home along Upper Bear Creek, establishing the International Bell Museum in 1957. Fascinated by bells since he was a child, Winston assembled a collection of over 4,000 bells of every type. Volunteers gathered annually to ring every bell on July 4th. Winston passed away in 2005, and the bell collection was donated to Hastings College in Nebraska.

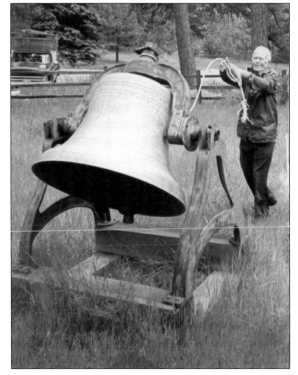

EVERGREEN FINE ARTS FESTIVAL. The year 1958 saw the formation of the Evergreen Artists' Association, and by 1966 they held an art festival on Main Street. In 1972, the group was incorporated as a nonprofit, and in 1980 the annual Evergreen Fine Arts Festival moved to Heritage Grove. It is one of the finest art fairs in the country, renowned for its sylvan pine grove setting and its quality artwork. (Courtesy of Josh Trefethen.)

STEVE REPAZ. Steve Repaz's boot and shoe repair shop has been located on Main Street, Evergreen, for nearly 40 years, making it the oldest business on the street under original ownership. Customers visiting Steve's shop enjoy the array of vintage World War I and World War II photographs, posters, and memorabilia filling every nook and cranny. Steve is active with the American Legion honor guard in Evergreen. (Courtesy of John Steinle.)

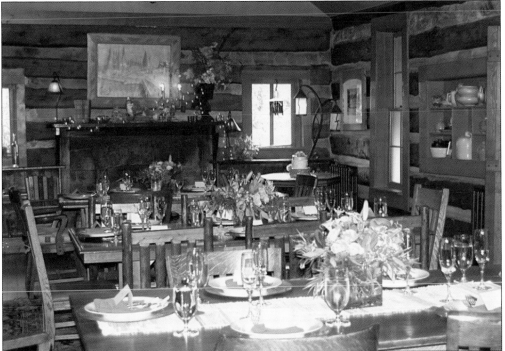

HIGHLAND HAVEN CREEKSIDE INN. Gail Riley and her husband, Tom Stratzell, bought several old summer cabins along Bear Creek in 1979. They opened in 1980 as the Highland Haven Resort Motel. The couple expanded and improved the buildings at the bed and breakfast, now known as the Highland Haven Creekside Inn. They have completely renovated the 1880s Dailey Cabin and breakfast is now served in its rustic atmosphere. (Courtesy of Highland Haven Creekside Inn.)

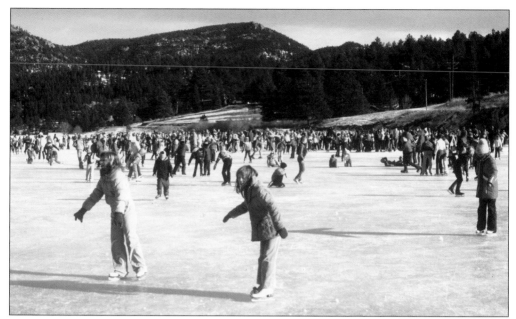

ICE SKATING ON EVERGREEN LAKE. Skating on Evergreen Lake is one of the most popular winter pastimes in the Evergreen area, and on New Year's Eve a local charity group called Drive Smart holds the Skate the Lake celebration, offering alcohol-free festivities and fireworks. Drive Smart was formed in 1993 to educate drivers, influence safety policies, and reduce the number of traffic fatalities. (Courtesy of Evergreen Park and Recreation District.)

KEYS ON THE GREEN. Jon Keyworth, famed Denver Broncos running back, and associates expanded the original 1920s golf clubhouse in the 1980s, creating a restaurant known as Keys on the Green, with spacious decks overlooking the golf course views. Restaurant patrons on the outside deck are sometimes bemused by the sight of golfers being interrupted by the elk herd!

EVERGREEN PLAYERS. The Evergreen Players began in the 1950s giving performances at the High School. By the mid-1960s, they performed in the old mission church space in St. Mark's House after the new Church of the Transfiguration was completed. In 2000, they began appearing in the former Evergreen Conference Meeting House, now known as Center Stage. The Evergreen Players have received state and national recognition for their outstanding productions.

EVERGREEN CHRISTIAN OUTREACH. Evergreen Christian Outreach (ECHO) began in 1987 to accept clothing, food, and other necessities to help the underprivileged at the Church of the Transfiguration. Helped by Evergreen Fellowship, by 1990 the organization was housed in the old Bancroft summer home. Here, people gather for the annual Turkey Trot, a three-mile walk around Evergreen Lake held on Thanksgiving morning since 2009 to benefit ECHO. (Courtesy of Evergreen Christian Outreach.)

RON LEWIS. One of Evergreen's most controversial citizens, Ron Lewis has had a huge impact on Evergreen as a high school wrestling coach, developer of multiple subdivisions, owner and manager of Evergreen Memorial Park, breeder of elk, deer, and buffalo, ordained Baptist minister, originator of church congregations, founder of Mountain Area Pregnancy Center, and crusader for conservative political causes. (Courtesy of Linda Kirkpatrick.)

EVERGREEN AREA CHAMBER OF COMMERCE. Community leaders formed the Evergreen Area Chamber of Commerce to support local businesses in the mid-1950s, by 1966 promoting Evergreen as "Blue Spruce Capital of the World." Chamber activities include member breakfasts and orientations, quarterly nonprofit meetings, a community calendar, a guide to businesses and cultural organizations, and a visitors' center. This photograph shows a benefit basketball game between the Harlem Ambassadors and a Chamber team. (Courtesy of Evergreen Area Chamber of Commerce.)

Eight

1990–2009

Combined efforts in the 1990s by multiple agencies and organizations led to construction of two of the most beloved structures in Evergreen: Evergreen Lake House and the new Evergreen Public Library.

Evergreen Lake House, opened in 1993, is one of the most popular venues in Evergreen for weddings, receptions, birthdays, and memorial services, plus community events, concerts, and fundraisers. Wonderful views of Evergreen Lake and the Evergreen Golf Course complement the inherent beauty of the building's log design. The Lake House is managed by Evergreen Park and Recreation District.

Evergreen Public Library was completed in December 1993. Enabled by a mill levy passed in 1986, the library was designed by Cabell Childress, who stated that it was based on elements he noted while attending the Evergreen Conference in the 1950s.

As former ranchland area was threatened with development, local citizens responded in 1993 when community efforts led by Linda Kirkpatrick and Chuck Hazelrigg raised $200,000 to help purchase the Noble Meadow area, now protected by a conservation easement and ownership by public agencies.

This effort was assisted by Mountain Area Land Trust (MALT), a nonprofit conservation group dedicated to saving pristine land through easements or ownership. One of the group's crowning achievements came with the purchase of the Beaver Brook Watershed and its protection through transfer of ownership to the US Forest Service.

The 1990s saw multiple additions to Evergreen's cultural life. A second history museum was added with the Humphrey History Park and Museum, preserving and interpreting the history of the Humphrey family and the Evergreen area through multiple programs and events. The founding of Evergreen Children's Chorale in 1991 offered opportunities for children to perform in concerts and musicals, while the extensive remodeling of Center Stage theater created a more welcoming theatrical venue. Finally, the opening of Center for the Arts Evergreen in 2004 gave the Evergreen area a community gallery and space for art classes and programs.

Evergreen events and people were covered extensively by new magazines and social media during the 1990s and 2000s, including the beautiful full-color *Serenity* and *Mountain Connection* magazines and the JustAroundHere.com webzine.

EVERGREEN CHILDREN'S CHORALE. Formed in 1991, Evergreen Children's Chorale was initially supported through a grant written by Jenise Harper, and the group's first productions were outstanding audience favorites. The chorale has continued its success story and presents choral concerts plus fully staged musicals. There are three groups of performers, ranging from second through eighth grades. This photograph features the group's original concert in 1991. (Courtesy of Evergreen Children's Chorale.)

CENTER FOR THE ARTS EVERGREEN. As part of creating Buchanan Park in 2004, a house was remodeled into the Center for the Arts Evergreen. Under Steve Sumner's leadership, the center offers gallery shows plus arts classes for adults and children, and annual art shows for high school and elementary students. In 2017, CAE is moving to a new location in a spacious historic former school and church building in Bergen Park. (Courtesy of Center for the Arts Evergreen.)

LINDA KIRKPATRICK. Linda Kirkpatrick has made a huge impact in Evergreen, especially in supporting its nonprofit organizations. In 1991, she started publishing a newspaper called *Upbeat*, featuring stories on the area's nonprofits, schools, and volunteer groups. She was instrumental in raising funds to build Evergreen's ambulance barn, and in saving Noble Meadow from development. Linda now edits JustAroundHere. com, focusing on community events and nonprofit organizations. (Courtesy of Linda Kirkpatrick.)

SUMMERFEST. After completion of new playing fields at Buchanan Park, Summerfest moved there in 2008 after many years in Heritage Grove. The event expanded beyond art and craft booths to offer music, beer tasting, and activities for children. Summerfest is the opening event for Arts Alive Evergreen, a 10-day series of art, performing, and cultural events held by many organizations throughout Evergreen. (Courtesy of Center for the Arts Evergreen.)

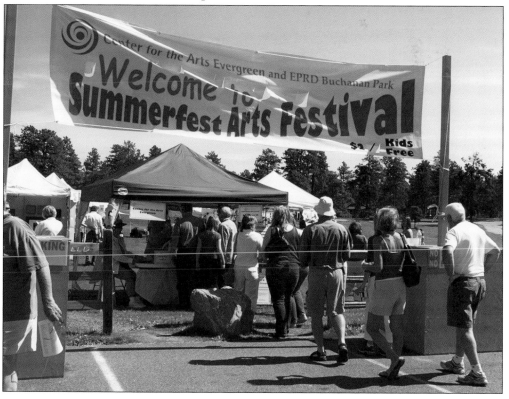

Buchanan Park Ball Fields. Playing fields were part of the creation of Buchanan Recreation Center and Buchanan Park in 2004. Schools use the fields for baseball, soccer, lacrosse, and other sports, and annual community events such as Summerfest and Big Chili are held there. The park, managed by Evergreen Park and Recreation District, also includes two trout ponds. (Courtesy of Evergreen Park and Recreation District.)

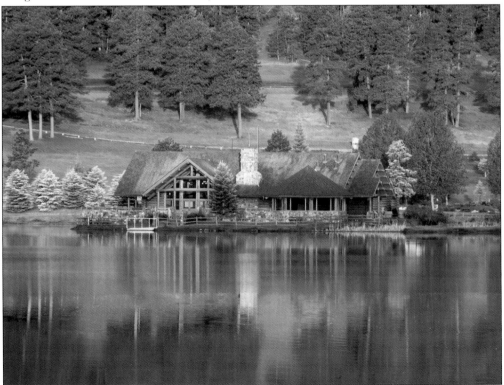

Evergreen Lake House. Evergreen Park and Recreation District describes its Lake House as the "crown jewel" of Evergreen. Completed in 1993, this massive log structure boasts of a huge patio and surrounding park enhanced with sculpture. The Lake House is booked solid each year with weddings, receptions, memorials, business meetings, and fundraisers. In the winter, ice skating is popular and the Lake House becomes the Skate Center. (Courtesy of Ron Ruhoff.)

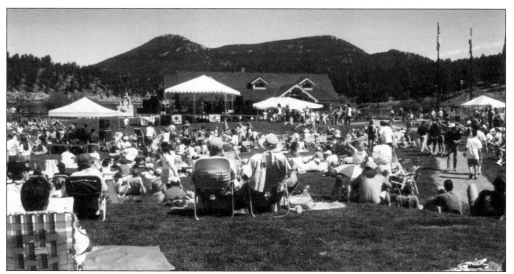

EVERGREEN LAKE SUMMER CONCERTS. Evergreen Park and Recreation District sponsors a popular open-air rock concert series every year at the Lake House from June to August. (Courtesy of Evergreen Park and Recreation District.)

NEW EVERGREEN LIBRARY. Through a bond issue passed in 1986, it became possible to construct a new Evergreen Library. The old brick high school was demolished, and a beautiful new library designed by Cabell Childress was built in its place, opening in 1993. Library facilities include exhibit space for artwork, computers for use by library patrons, a children's book and storytelling area, and several meeting rooms. (Courtesy of John Steinle.)

Mountain Area Land Trust. Mountain Area Land Trust (MALT) was founded in 1992 and was involved in efforts to save Noble Meadow (pictured) from development. After obtaining nonprofit status, MALT has saved almost 15,000 acres of land from development through ownership and conservation easements. MALT works extensively with other agencies such as Jefferson County Open Space, Greater Outdoors Colorado, Clear Creek Conservancy, US Forest Service, and others to accomplish its goals. (Courtesy of Ron Ruhoff.)

BOOTSTRAPS. Evergreen Woman's Club, Evergreen High School PTA and other residents organized Evergreen Scholarships Association in 1945 to offer scholarships to graduating seniors from Evergreen High School. In 1992, ESA merged with Bootstraps, an Evergreen group offering interest-free loans to local college students. The combined organization, known simply as Bootstraps, has granted more than $3.5 million in scholarships and loans since 1945. (Courtesy of Bootstraps.)

HUMPHREY HISTORY PARK AND MUSEUM. When Hazel Humphrey passed away in 1995, she left an endowment to create a museum at her property. It opened as Humphrey Memorial Museum and Park, now the Humphrey History Park and Museum, in 1996. Under leadership of Angela Rayne, the museum expanded events and facilities, creating a gift shop, tea room, and an events area in the old croquet court. (Courtesy of Humphrey History Park and Museum.)

HUMPHREY MUSEUM SCHOOL TOUR. School group tours are only one type of event held at the Humphrey Museum. Others include the Hay Days Harvest Festival, children's backpack tours, art exhibits, cooking and fiber arts classes, murder mystery dinners, wine tastings, and many others. The museum, which includes multiple vintage buildings on the former Humphrey property, is open from May through September. (Courtesy of Humphrey History Park and Museum.)

EVERGREEN JAZZ FESTIVAL. Longtime jazz fan Sterling Nelson originated the idea for an Evergreen Jazz Festival in 1999. A growing number of jazz enthusiasts joined in, and by 2001 the first festival was held. Since then, the Evergreen Jazz Festival expanded to include venues at the Elks Lodge, Lake House, and Evergreen Christian Church. The festival draws outstanding jazz bands and fans from across the country. (Courtesy of Linda Kirkpatrick.)

JEANNIE AND TED MANN. After moving to Evergreen from Denver in 1977, Ted and Jeannie Mann became involved in multiple groups supporting the community. From the Evergreen Chamber of Commerce to Leadership Evergreen, Art for the Mountain Community, Jefferson County Library Foundation, National Repertory Orchestra, Arts Alive Evergreen, Jefferson County Horse Council, and especially Evergreen Jazz Festival, Ted and Jeannie lent their wise counsel until Ted's death in 2015. (Courtesy of Linda Kirkpatrick.)

BRIDGE CONTROVERSY. In 2005, Jefferson County Open Space installed a steel bridge connecting downtown Evergreen with trails surrounding Evergreen Lake. The massive steel structure seemed out of proportion to its surroundings to large numbers of Evergreen residents, and protests were organized to promote removal of the bridge. Finally, Open Space graciously consented to remove it. It was later installed on Clear Creek near Golden. (Courtesy of Evergreen Park and Recreation District.)

SCULPTURE EVERGREEN. Originally known as Art for the Mountain Community, Sculpture Evergreen was formed in 1994 to enhance Evergreen with both permanent and temporary installations of high quality sculpture. Since then, 29 permanent sculptures have been installed around Evergreen, and the group holds the annual Sculpture Walk that draws large attendance. "Morning Spirits" by Susan Geissler in downtown Evergreen is one of the most popular artworks. (Courtesy of John Steinle.)

CONGREGATION BETH EVERGREEN. Famed author Joanne Greenberg carries the Torah at the 2004 dedication ceremony for Congregation Beth Evergreen synagogue. In 1974, Evergreen resident Bernie Goldman advertised for fellow Jews to join him for High Holy Days celebrations. As the congregation grew, they met at Greystone Lodge, then at the United Methodist Church until building their own synagogue. Congregation Beth Evergreen affiliates with the Jewish Reconstruction Foundation. (Courtesy of David Weihnacht.)

ASTRONAUT JEFFREY S. ASHBY. Though born in Dallas, Jeff Ashby grew up in Evergreen, graduating from Evergreen High School in 1972. During his Navy pilot career, he flew combat missions in Iraq and Somalia, plus commanding a Navy fighter squadron aboard USS *Abraham Lincoln*. Later, he served on three space shuttle missions, assisting in construction of the International Space Station, and logging more than 600 hours in space. (Courtesy of Linda Kirkpatrick.)

LARIAT LOOP NATIONAL SCENIC BYWAY. Lariat Loop National Scenic Byway is an alliance formed in 1998 by a group of regional cultural organizations. The Lariat Loop route includes such sites as the Buffalo Bill Museum and Grave, Hiwan Heritage Park, Humphrey History Park and Museum, Dinosaur Ridge, and Red Rocks Amphitheater. Here, children participate in the Wildflower Festival at Lookout Mountain Nature Center. (Courtesy of Lookout Mountain Nature Center.)

EVERGREEN NATURE CENTER. The Evergreen Nature Center was originally built by the Civilian Conservation Corps in the 1930s as the warming hut for skaters. A fire and deterioration in the 1990s led to a lengthy process of renovation by Evergreen Park and Recreation District. With help from the State Historical Fund, the building was restored and now holds Evergreen Nature Center, offering exhibits and programs relating to local wildlife. (Courtesy of Evergreen Audubon.)

EVERGREEN SCENIC VIEW. Tom Bergen's 1859 comment on the beauty of the Evergreen area holds true today, despite the enormous growth in population and development. One of the outstanding things about Evergreen is how its residents have protected and sustained the natural beauty of the area. (Courtesy of Ron Ruhoff.)

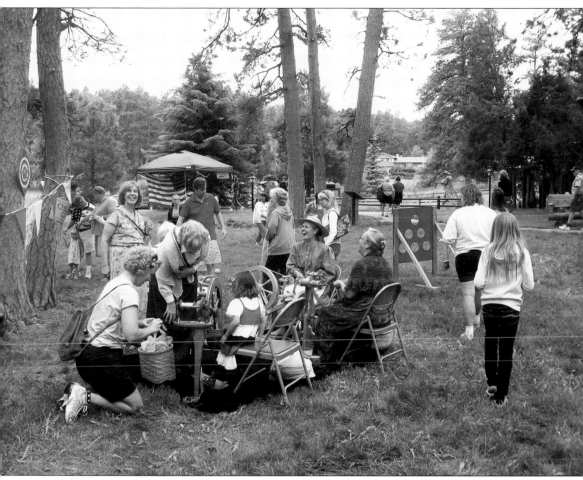

EVERGREEN 150TH ANNIVERSARY CELEBRATION. On July 4, 2009, Evergreen celebrated the 150th anniversary of Thomas Bergen completing his first cabin with a community celebration at Hiwan Homestead Museum and Heritage Grove. Reenactors portrayed Bergen and his family, traditional crafts were demonstrated, and period brass band music was played. A big Evergreen birthday cake was enjoyed by everyone present. And there was much speculation about what the next 150 years would bring to Evergreen.

BIBLIOGRAPHY

Alderfer, Hank and Barbie. *Yesteryear: Tales from Colorado Front Range Communities.* 2016.

Bentley, Margaret V. *The Upper Side of the Pie Crust, An Early History of Southwestern Jefferson County Conifer–Pine–Buffalo Creek, Colorado.* Evergreen, CO: Learning Pathways, Inc., 1978.

Brookfield, Ruth Steele. *The History of a Parish: In Celebration of the Centennial of the Church of the Transfiguration, 1899–1999.* William R. Borchelt, 1999.

Crain, Mary Helen. *A Circle of Pioneers.* Tri-Canyon Publishing Co.

———. *Evergreen, Colorado.* Evergreen, CO: Jefferson County Historical Society, 1969.

Crofutt, George. *Crofutt's Grip-Sack Guide of Colorado.* Omaha, NE: Overland Publishing Company, 1885.

Douglas, Anne Woodward, and Ellinwood, Leonard. *To Praise God: The Life of Canon Charles Winfred Douglas.* New York: The Hymn Society of America, 1958.

Fahnestock, Connie. *From Camp Neosho to the Hiwan Homestead.* Englewood, CO: Quality Press, 1985.

Hamilton, C.M. *Our Memories of Bergen Park.*

Kempes, Leslie Polling. *Ladies of the Canyons.* Tucson, AZ: University of Arizona Press, 2015.

Moynihan, Betty, and Waters, Helen E., ed. *Mountain Memories: From Coffee Pot Hill to Medlen Town, A History of the Inter-Canyon Area of Southwest Jefferson County.* Lakewood, CO: Limited Publications, 1981.

Porter, Candy. "Evergreen Conference Then and Now," *The Record.* Jefferson County Historical Society Newsletter, fall/winter 2016.

Shellenbarger, Melanie. *High Country Summers: The Early Second Homes of Colorado, 1880–1940.* Tucson, AZ: University of Arizona Press, 2012.

Sternberg, Barbara, with Jennifer Boone and Evelyn Waldron. *Anne Evans–A Pioneer in Colorado's Cultural History: The Things That Last When Gold Is Gone.* Center for Colorado and West Auraria Library, 2011.

Sternberg, Eugene and Barbara. *Evergreen, Our Mountain Community.* Boulder, CO: Evergreen Kiwanis Foundation, Johnson Publishing Company, 2004.

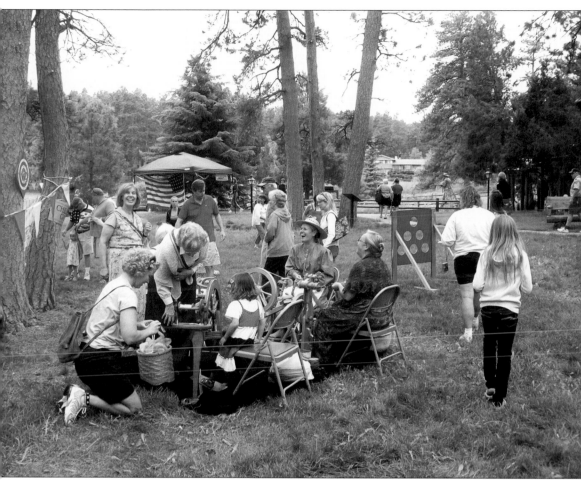

Evergreen 150th Anniversary Celebration. On July 4, 2009, Evergreen celebrated the 150th anniversary of Thomas Bergen completing his first cabin with a community celebration at Hiwan Homestead Museum and Heritage Grove. Reenactors portrayed Bergen and his family, traditional crafts were demonstrated, and period brass band music was played. A big Evergreen birthday cake was enjoyed by everyone present. And there was much speculation about what the next 150 years would bring to Evergreen.

BIBLIOGRAPHY

Alderfer, Hank and Barbie. *Yesteryear: Tales from Colorado Front Range Communities*. 2016.

Bentley, Margaret V. *The Upper Side of the Pie Crust, An Early History of Southwestern Jefferson County Conifer–Pine–Buffalo Creek, Colorado*. Evergreen, CO: Learning Pathways, Inc., 1978.

Brookfield, Ruth Steele. *The History of a Parish: In Celebration of the Centennial of the Church of the Transfiguration, 1899–1999*. William R. Borchelt, 1999.

Crain, Mary Helen. *A Circle of Pioneers*. Tri-Canyon Publishing Co.

———. *Evergreen, Colorado*. Evergreen, CO: Jefferson County Historical Society, 1969.

Crofutt, George. *Crofutt's Grip-Sack Guide of Colorado*. Omaha, NE: Overland Publishing Company, 1885.

Douglas, Anne Woodward, and Ellinwood, Leonard. *To Praise God: The Life of Canon Charles Winfred Douglas*. New York: The Hymn Society of America, 1958.

Fahnestock, Connie. *From Camp Neosho to the Hiwan Homestead*. Englewood, CO: Quality Press, 1985.

Hamilton, C.M. *Our Memories of Bergen Park*.

Kempes, Leslie Polling. *Ladies of the Canyons*. Tucson, AZ: University of Arizona Press, 2015.

Moynihan, Betty, and Waters, Helen E., ed. *Mountain Memories: From Coffee Pot Hill to Medlen Town, A History of the Inter-Canyon Area of Southwest Jefferson County*. Lakewood, CO: Limited Publications, 1981.

Porter, Candy. "Evergreen Conference Then and Now," *The Record*. Jefferson County Historical Society Newsletter, fall/winter 2016.

Shellenbarger, Melanie. *High Country Summers: The Early Second Homes of Colorado, 1880–1940*. Tucson, AZ: University of Arizona Press, 2012.

Sternberg, Barbara, with Jennifer Boone and Evelyn Waldron. *Anne Evans–A Pioneer in Colorado's Cultural History: The Things That Last When Gold Is Gone*. Center for Colorado and West Auraria Library, 2011.

Sternberg, Eugene and Barbara. *Evergreen, Our Mountain Community*. Boulder, CO: Evergreen Kiwanis Foundation, Johnson Publishing Company, 2004.

INDEX

Alderfer Ranch, 69, 73
Alderfer family, 73, 94, 95, 101
Anderson family, 36, 77
Bergen, Thomas and Judith, 7, 9, 13, 22, 125
Blue Spruce Kiwanis Club, 77, 78
Center for the Arts Evergreen, 102–115
Center Stage Theater, 92, 93, 113
Christ the King Catholic Church, 84
Colorado Philharmonic, 8, 79, 81
Congregation Beth Evergreen, 122
Dedisse Ranch, 18
Dedisse family, 9, 18
Denver Mountain Parks, 8, 37, 40, 4, 83,
Douglas, Charles Winfred, 30, 38, 62, 66, 75
Douglas, Dr. Josepha Williams (Dr. Jo), 29–31,
 33, 50, 66
Episcopalian Mission (Church) of the
 Transfiguration, 23, 32, 33, 63, 75, 84
Evans, John, 7, 15, 16, 42, 95
Evergreen Artists Association, 8, 69, 108
Evergreen Audubon, 8, 87, 93
Evergreen Chamber of Commerce, 81, 82, 112,
 121
Evergreen Children's Chorale, 8, 113, 114
Evergreen Chorale, 8, 92, 105
Evergreen Christian Outreach, 32, 99, 111
Evergreen Conference, 51, 65, 74
Evergreen Dam, 18, 51, 60, 61
Evergreen Elks Club, 92
Evergreen Fire Rescue, 8, 80, 95, 105
Evergreen Garden Club, 88
Evergreen High School, 64, 65, 98
Evergreen Lake, 51, 60, 61, 71, 110
Evergreen Nature Center, 61, 124
Evergreen Park and Recreation District,
 8, 60, 83, 88, 94, 110, 113, 116, 117, 121, 124
Evergreen Players, 8, 69, 111

Evergreen Rodeo, 8, 76, 77
Evergreen Rotary Club, 93, 98
Evergreen Volunteer Fire Department, 69, 73,
 75, 81, 105
Greystone Lodge, 7, 39, 46, 47, 122
Hayden Family, 95
Heritage Grove, 90, 102, 125
Highland Haven Creekside Inn, 32, 99, 109
Hiwan Golf Club, 107
Hiwan Homestead Museum (Hiwan Heritage
 Park), 7, 8, 38, 63, 83, 89, 90, 93, 103, 123,
 125
Hiwan Ranch, 70, 107
Humphrey History Park and Museum, 8, 113,
 119, 120
International Bell Museum, 8, 69, 107
Jefferson County Historical Society, 8, 81, 83,
 89, 90, 94, 95, 101
Jefferson County Open Space, 8, 48, 83, 87, 89,
 90, 101, 118, 121
Lariat Loop National Scenic Byway, 123
Little Bear Saloon, 52, 96, 100
Lutheran Church of the Cross, 78
Mount Evans Hospice, 104
Mountain Area Land Trust, 8, 94, 113, 118
Olde's Filling Station and Garage, 53, 56, 72
Post family, 9, 19, 22, 23
St. Mark's Episcopalian Church, 9, 20, 23, 33
Sculpture Evergreen, 122
Spence, John "Jock," 38, 39, 42, 49, 50
Troutdale Hotel, 7, 51, 57, 58, 59, 69
Wilmot, Dwight, 9, 17, 20, 97
Wilmot Elementary School, 97

DISCOVER THOUSANDS OF LOCAL HISTORY BOOKS FEATURING MILLIONS OF VINTAGE IMAGES

Arcadia Publishing, the leading local history publisher in the United States, is committed to making history accessible and meaningful through publishing books that celebrate and preserve the heritage of America's people and places.

Find more books like this at
www.arcadiapublishing.com

Search for your hometown history, your old stomping grounds, and even your favorite sports team.